DRAWING ᴬᴺᴰ CARTOONING 1,001 FIGURES IN ACTION

DRAWING AND CARTOONING 1,001 FIGURES IN ACTION

Dick Gautier

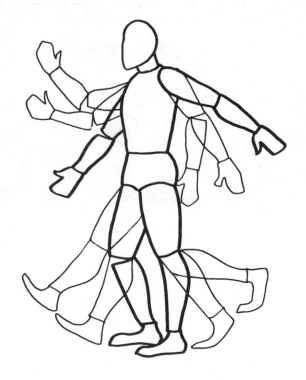

A Perigee Book

Perigee Books
are published by
The Berkley Publishing Group
200 Madison Avenue
New York, NY 10016

Library of Congress Cataloging-in-Publication Data

Gautier, Dick.
 Drawing and cartooning 1,001 figures in action / Dick Gautier.
 p. cm.
 "A Perigee Book."
 ISBN 0-399-51859-2
 1. Figure drawing—Technique. 2. Cartooning—Technique.
 I. Title. II. Title: Drawing and cartooning one thousand one figures in action.
NC765.G33 1994 93-48235 CIP
743′.4—dc20

Cover design by Bob Silverman, Inc.
Printed in the United States of America
1 2 3 4 5 6 7 8 9 10

This book is printed on acid-free paper.
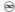

CONTENTS

INTRODUCTION

When I was a boy I was fascinated by the human body. I was astounded by the fact that a skeletal structure held together with muscles and tendons and filled with a whole mess of organs and then covered by a big sheet of skin boasting occasional tufts of hair, could be as versatile as it is. It has the ability not only to perform a wide variety of actions, but also to express so much with its incredible range of motion. From the smallest, subtlest gesture which can speak volumes, to the most outrageously bizarre convolutions of the latest dance craze, the human body has virtually no limitations insofar as expressiveness is concerned. It is capable of communicating not only exquisite grace and beauty but, in the very next moment, the grotesque or the violent. Words cannot possibly capture the myriad movements, positions, stances, attitudes, and poses of which our bodies are capable and, incidentally (to get to my point, finally), neither can this book.

I couldn't possibly take you on a tour of every possible variation in movement of the human body, but what I will do is give you a working knowledge of its basic measurements, its limitations, its capabilities; in other words, fill up your boat with all the necessary information and then set you out to sea on your own.

Drawing the human body, like all art, is initially a trial-and-error process, and in this book we are also going to tackle not only the true dimensions of the human body but also those humorous distortions that we call cartooning. Cartoons pinpoint specific aspects of the human body and exaggerate them, opening up limitless possibilities to an already seemingly limitless horizon.

However even cartooning must have its guidelines and restrictions in order for the human form to be represented correctly no matter how outrageous,

bizarre, comical or broad the distortion may be.

Insofar as the normal figures go, I'm going to avoid the very technical approach embraced by some teachers, i.e. to picture and demonstrate the movements of all the bones and muscles of the body and urge you to memorize their names. Personally I don't see the value in knowing a femur from a tibia or a latisimus dorsi from a gluteus maximus. I'd rather we concentrate our learning energies in another direction . . . how a body moves. Not that it isn't important to understand the muscles' functions, movements, and limitations, but I feel that the names are, at this point, irrelevant to what we are trying to accomplish in this particular book.

Even though an artist draws only the surface of the body, we should "feel" the mass and substance below the exterior. It is important for us to understand the functions of those muscles, tendons, ligaments, and bones, as well as their limitations. You will, in time, learn to recognize their capabilities and be able to convey the human body in all its splendor, grace, clumsiness, awkwardness, and beauty . . . in short, all the things that make up and express the incredibly wide physical range we are capable of. We will run the physical action gamut from A to Z, from Apathetic lounging to Zesty sports activities. I realize that the title of this book is *1001 Figures in Action*, but "action" is a relative term; to the sedentary couch potato, making a trip to the kitchen could be considered effort, but not so to the Type A hyperpersonality. We are going to begin easily and slowly with smaller everyday movements like standing, leaning, sitting, and the like, but then as the chapters progress, we'll move into more strenuous activities such as manual labor, sports, dance, etc. So hang in with me on this fascinating journey. I know it will be worth your while.

DRAWING AND CARTOONING 1,001 FIGURES IN ACTION

BASICS

Leonardo da Vinci's classic sketches of
the human form have served as models
for artists for generations, and since he
and other artists of his era saw fit to use
the human head as a measuring tool, we
still utilize his basic dimensions: from
7½ to 8 heads for the average
male figure, and anywhere from 6 to
7½ heads for the female. Of course
these are only approximations plus the
fact that our world has undergone some
pretty radical genetic changes since the
16th century so women cannot be
comfortably pigeonholed any longer
since I, at six feet tall, often find myself
staring up into the eyes of a salesgirl,
business associate, and on occasion even
a date. But I'm not threatened . . . I'm
not. Honest.
We must approach each and every body
on the basis of its individual dimensions,
merits, or flaws. The physical "norm,"
whatever that mythological thing may
be, is constantly adapting to our
society's changing beliefs about what a
body should look like.

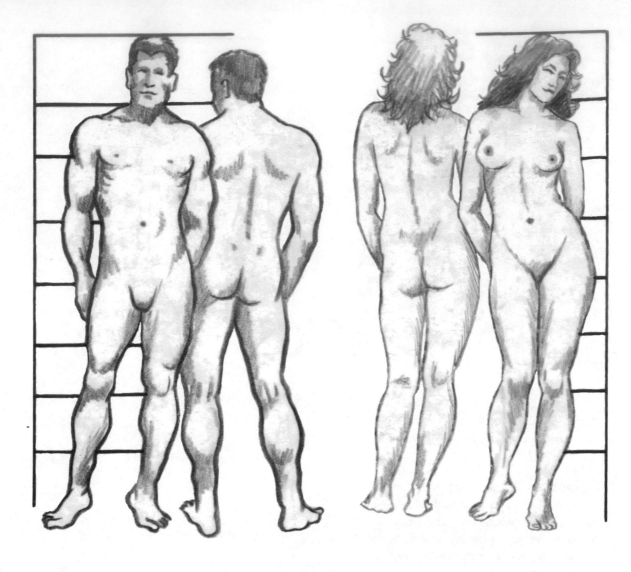

You can see that the male form fits easily into the 8-head concept . . .

but then so can the female figure and, in so doing, it lends her more grace and power. She seems less squat, less compressed, more lithe, and better proportioned. So especially in cases where you intend to glamorize or idealize the female form, I recommend adding a head or 1½ heads to those proportions in order to add that dignity and grace.

Although I'm well aware that there are many exceptions to this rather shaky rule, for our purposes, let's use 8 heads for the male and 7 for the female. Those who disagree, please be advised that these dimensions are for purposes of demonstration only. There are no sociological or judgmental implications here. I'm just trying to make my job a little easier.

Please note that each head length falls at some easily identifiable spot on the body, so you can always double-check your proportions for accuracy. The second head on both the male and female figures begins just below the chin and ends at the nipples, while the third goes from nipples to navel. The fourth ends at the crotch, representing the halfway mark of the body; the fifth head stops at the end of the fingertips; the

sixth at the bottom of the knee; the seventh just below the swell of the calf muscle where it begins tapering gently into the ankles (the only really non-specific measuring area); and the eighth to the floor. From the rear some of the same measurements apply but there are some others that are useful. For instance the "nipples" measurement in the back view is just below the shoulder blades. The navel is equivalent to the waist.

The reason I mention these rather primary drawing techniques is that one of the first mistakes made by some artists when they introduce motion into a figure is unintentional distortion. There are several different ways to monitor your proportional accuracy. First we could use the double triangle device. As you can see in this sketch, if you were to use one triangle from the shoulder to the center of the body, and then another inverted triangle from the hips to the neck, you would have constructed a fair approximation of the upper part of the body.

Simple, but you can see how this gives you a pretty good semblance of the distribution of masses in the human form.

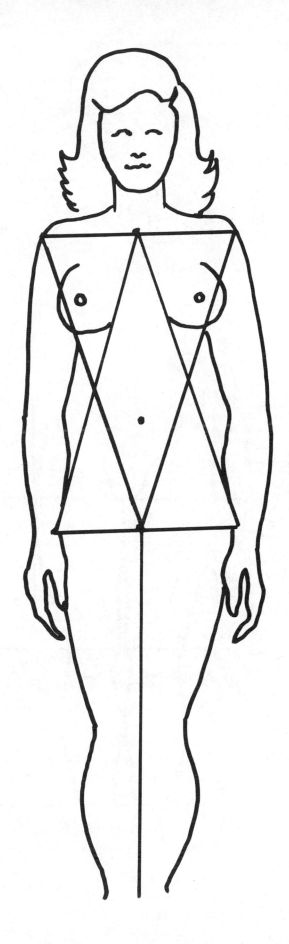

Now let's move on to more specific measurements: In the 8-head male figure, the shoulders are approximately 2 head lengths wide, his hips about 1½.

In the female it's just the opposite: Her shoulders are 1½ and the hips are 2 full heads wide.

The width of a man's hips are equal to a length beginning just below his scrotum to the bottom of his kneecap and the same length again from there to his ankles. So you see, there are many little measuring devices you can use to monitor the figure as you prepare a sketch.

There are other pronounced differences between the male and female figures. Again these are harsh generalizations (we do not take individual exercise regimens into account): Females have slightly more fat on their bodies, which gives them a softer, more rounded look; the neck is more slender and delicate as are the facial features; her waist is higher, her legs are smoother, and her thighs are slightly fuller than the male's. Please keep these in mind as you begin a sketch, and you'll begin to zero in on those differences (God bless them). Soon they'll become an automatic part of your work—second nature as it were.

Needless to say (or maybe it is needed), if you choose to elongate the figure for reasons of grace or glamorization, the other elements must follow suit. For instance the arms and legs also must be made longer to keep the proportions in constant harmony. You don't want to end up with aberrations like a terribly short-armed gentlemen or a woman whose long arms lend her a simian appearance.

So far, of course, we've been dealing with only the "ideal" form, but since the majority of human beings don't fall in to that category (MTV videos, Playboy and Playgirl magazines notwithstanding), let's deal with some less-than-perfect bodies and I'll demonstrate how the slightly obese or slender build still adheres to the same basic principles and measurements.

The major differences here are in the man's hip width and the woman's hip width, hers being narrower and his much wider because of his added weight.

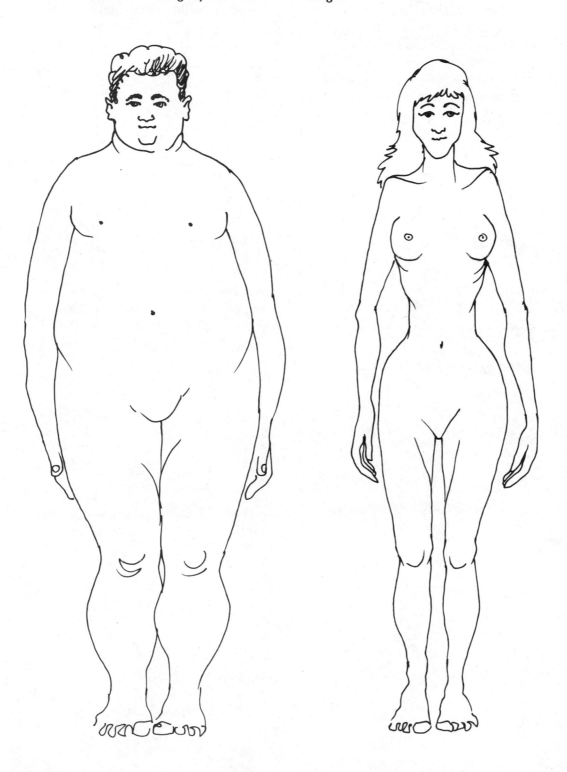

In the beginning, to incorporate movement into the human form, it's sometimes valuable to divorce oneself from the "humanity" of the figure (just ask Dr. Frankenstein). What I mean by that is, let's reduce the human body to a group of tubes and shapes, more like sections of a disassembled marionette than a flesh-and-blood human being. It simplifies our task in the beginning so that we can feel the mass and the interior weight of the body, and also it helps to keep us honest, so that we're not as guilty of unwanted distortion.

Now you can picture the torso moving, bending, and stooping while still maintaining its proportional integrity. As you can see, any way that I move the limbs on this imaginary model (they do, in fact, exist and are sold at better art stores), they can only respond, i.e. bend, flex, etc. with the same restrictions as the human body.

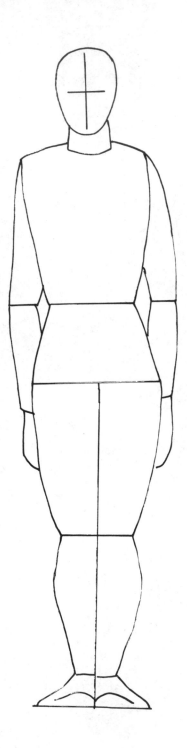

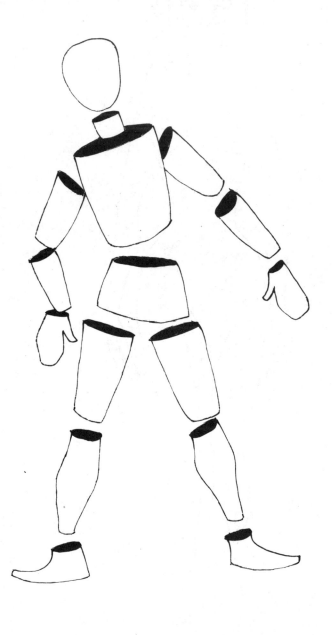

Here's how to animate this marionette
figure:

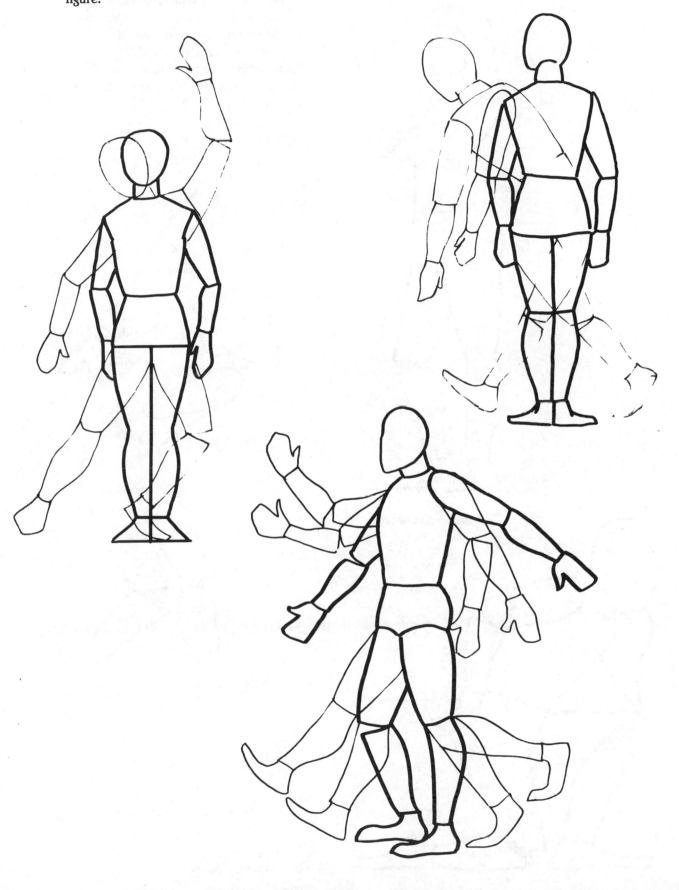

The basic components never change shape or size—they bend and flex in keeping with the movement. The same should be reflected when you draw a stooping, bending, or crouching figure. Each section retains its dimensional character no matter what position is assumed.

Let's position it like a baseball player . . .

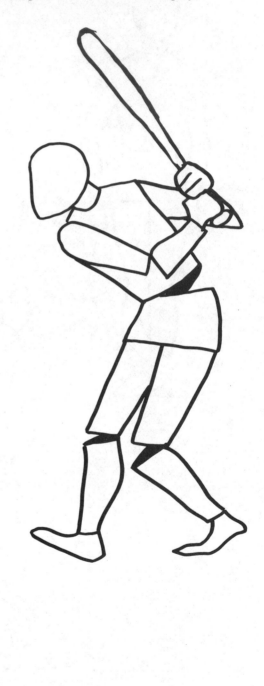

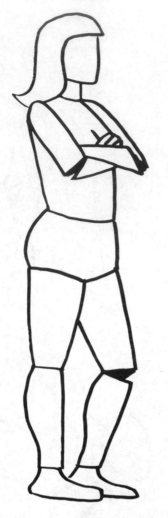

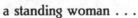

a standing woman . . .

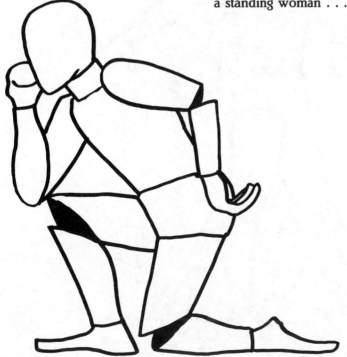

a "Thinker"-like pose . . .

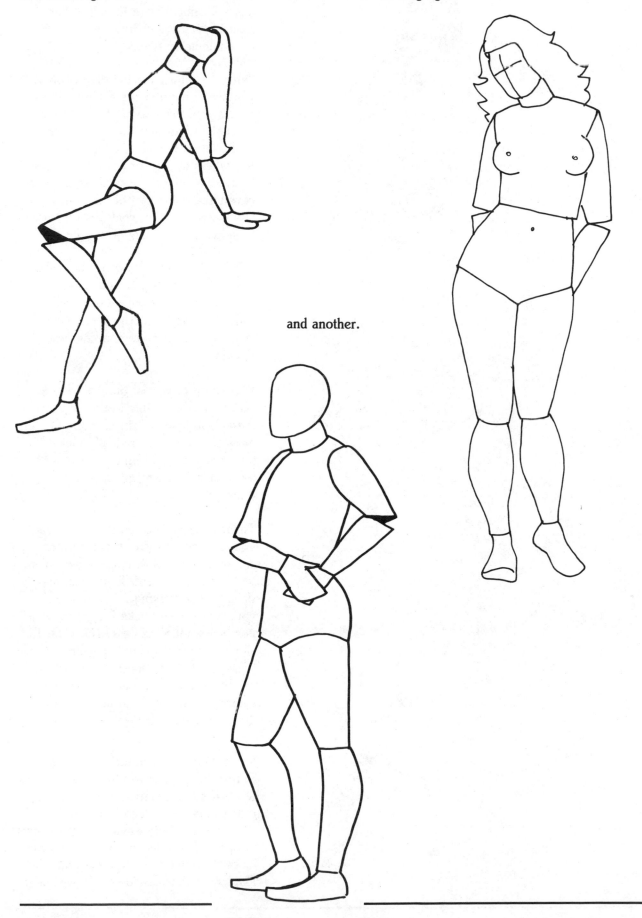

and another.

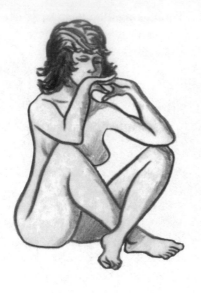

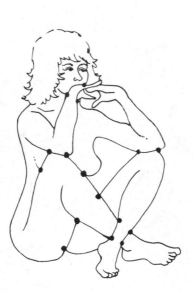

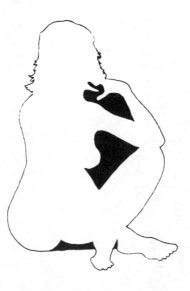

There are other self-monitoring devices that you should learn to utilize. For instance, study this drawing carefully for a minute or two.

Now . . . which specific things could you use to monitor the anatomical accuracy of this drawing? Locate those points I've indicated, where the line of the breast intersects with the leg, where the arms rest on the knees, where the ankles cross, where the hand covers the lower part of the face, etc. Use these as further guideposts in order to verify the accuracy of the sketch.

It is also valuable to picture the negative forms in a drawing, to concentrate not only on the figure but on the areas that show through her body. It can help you to achieve a truer, more accomplished drawing.

In the future, when you approach a sketch, you'll be able to use any one of these techniques to check your progress, and then gradually make minor adjustments until it all comes together as a proportionally correct drawing.

Then, once you've achieved that goal, you can begin to stretch and shorten and play gently with those dimensions to add your own artistic nuances and slants to the drawing . . . to make it your own . . . to make it express what it is *you* want to express. That's the all-important artistic individuality that we strive for, but you must understand and be able to render a true drawing initially before you are ready to move on to distort and individualize.

Incidentally, I realize that it's expensive and/or problematic to obtain the services of models (either family members, professionals, or friends), so I often choose to use books and magazines such as *Sports Illustrated* or *Dance Magazine* for certain references. Also magazines like *Playboy*, various fashion catalogues, etc.,

offer a fairly wide range of models to suit your needs—dressed, partially dressed, and, on occasion, completely undressed. There are also several good nude reference manuals available at better art stores (not inexpensive but valuable). But, I prefer going to the source in order to view people doing pedestrian things. I usually bring a sketchbook with me to restaurants and quickly capture people sitting at tables, talking, eating, etc. I do fast and facile impressions, not getting caught up in detail. Then later, if I choose, I can work them up into more fully realized drawings. I can't recommend this practice too highly. It keeps your hand-eye observational powers sharply honed and you come across positions and movements you just never dreamed existed. I also recommend doing this at museums, libraries, and especially the beach (if you have one nearby) where you can observe all kinds of more extreme physical activities. A playground, obviously, is the ideal spot to catch children in all sorts of interesting positions, unless of course you have kids of your own.

When executing these loose, quick drawings, you don't always have to sketch within the measurements. Try to render the outline of the figure, test your powers of observation, compare spatial relationships closely, and capture the movement of the figure in that fashion. Also remember that these are merely reference sketches to be developed in more detail at a later time. Don't aim for ultra-realism or detail. Instead, concentrate on the ''essence'' of the pose.

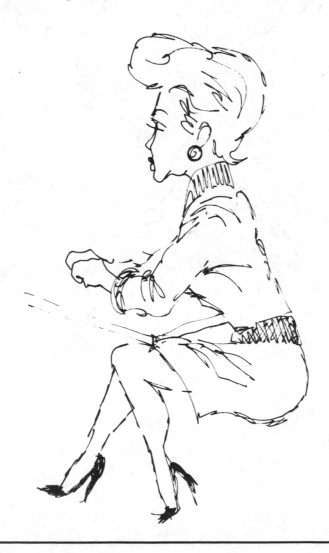

Here's another exercise: Don't lift your pen or pencil off the paper—work in one continuous line. Who cares how it comes out? It may help you loosen your approach to your work.

Incidentally, the reason we deal with so many nude figures in this book is simple: The curves and stresses and muscular tensions, etc., are invaluable for the artist to learn, and these can be seen only on the unclothed figure. The model that is dressed presents an entirely new set of challenges, such as drawing accurately the drapes and folds of soft fabrics, and the sharp, angular wrinkles of harsher materials. Clothing very often serves to mask action and movement, so in this book the majority of drawings will be nudes.

If you learn how to double-check each minute spatial relationship, soon you will be able to amend easily whatever accidental distortions you might come across. But the name of the game, of course, is practice: Sketch wherever and whenever you can. It's something you can never overdo. I'm continually amazed to discover yet another pose, position, stance, some new wrinkle of which the human body is capable. So toss a drawing pad and pencil in your car, carry one in your briefcase, purse, or whatever (they come in all sizes), and have access to it at all times. You never know when you might spy a couple locked in an embrace that deserves to be captured on paper, or a child playing in a sandbox whose body language cries out to be frozen in time. So just remember and apply the three Ps: paper, pencil, and persistence.

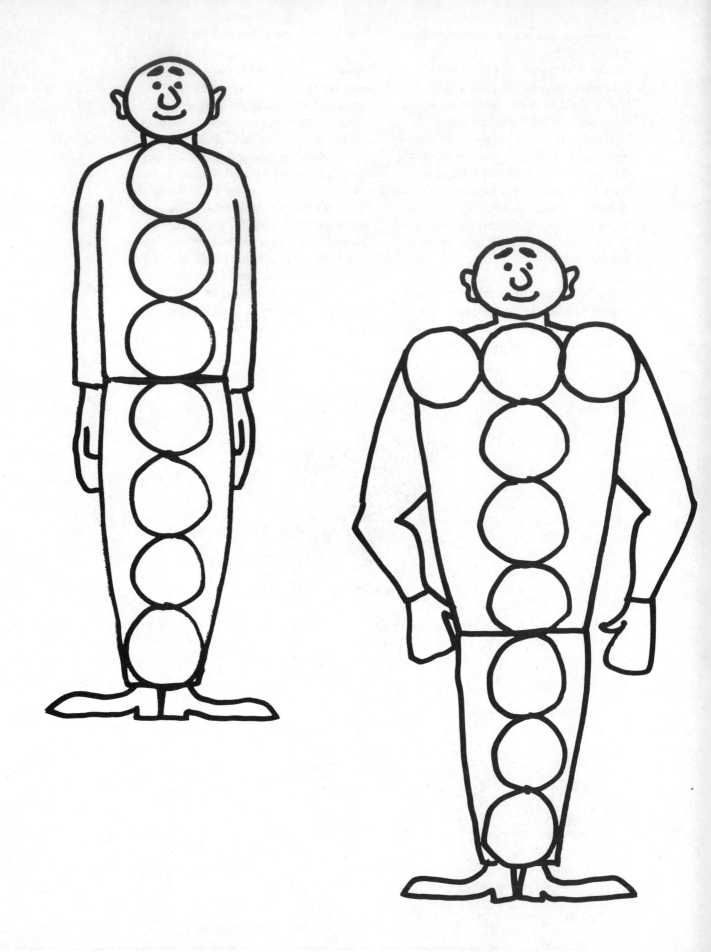

CARTOONING

Now comes the fun part. When we cartoon, much like the jazz improvisor who understands the harmonic structure of a piece of music so well that he or she can successfully stray from the melody and find all sorts of interesting variations, we, as artists, have to be totally knowledgeable of and comfortable with the basic body dimensions before we can successfully distort them: Let's take our rudimentary principles and have some fun with them.

First let's apply the 8- and 7-head principle to a cartoon character. . . .

It doesn't really work, does it? The cartoon body has to be distorted to begin with so that the rest can follow suit. As an example, if we were to drop the waistline way below where it would ordinarily be on this figure, you can see that it would accentuate his chest and minimize his lower body, thus lending him a distorted but comically powerful look.

So if I wanted to draw a well built, chesty, tough guy, or he-man, I'd probably use this simple distortion, which would, in turn, lead to these health club type denizens:

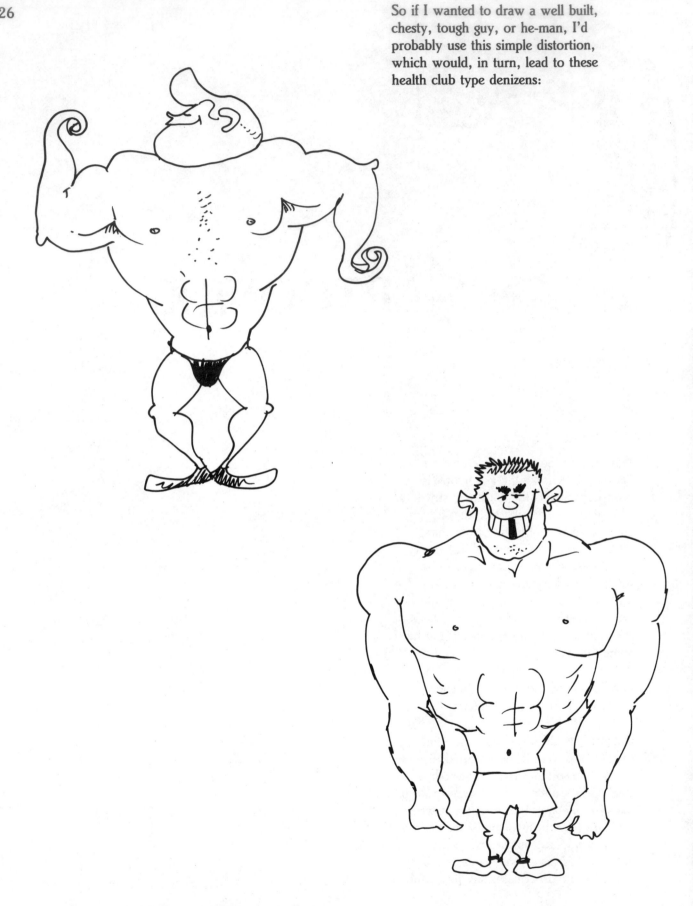

On the other hand, if I want to draw some out-of-shape guy, I'd narrow his shoulders and raise his waist, giving him a less ample chest . . . which would eventually inspire this sort of a chap:

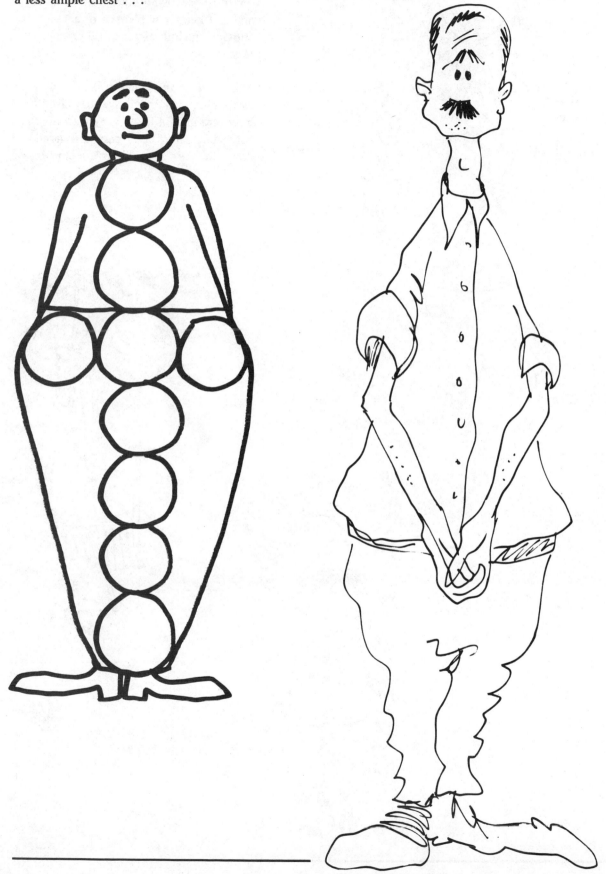

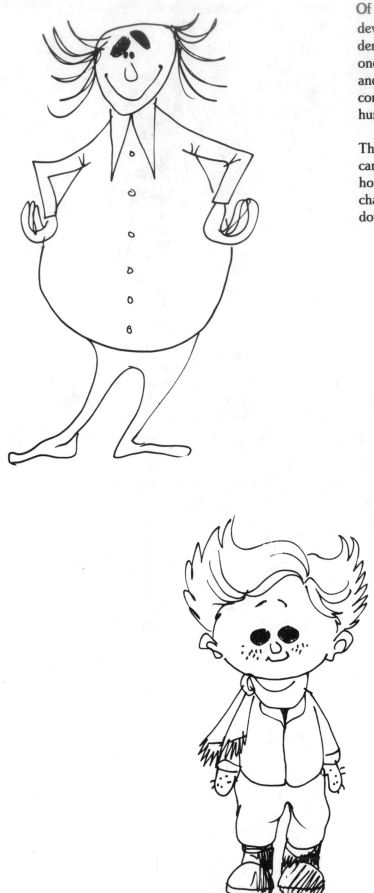

Of course these are overly simplistic devices but I include them here to demonstrate how easily, in cartooning, one can distort the body (within limits) and still keep a semblance of a convincing, humorous or otherwise, human form.

The name of the game in most cartooning is simplicity. You will note how few lines it takes to suggest a character. Their body parts are pared down to mere suggestions in some cases.

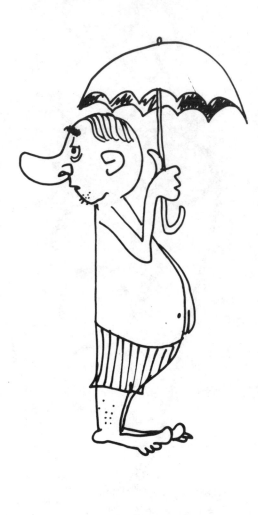

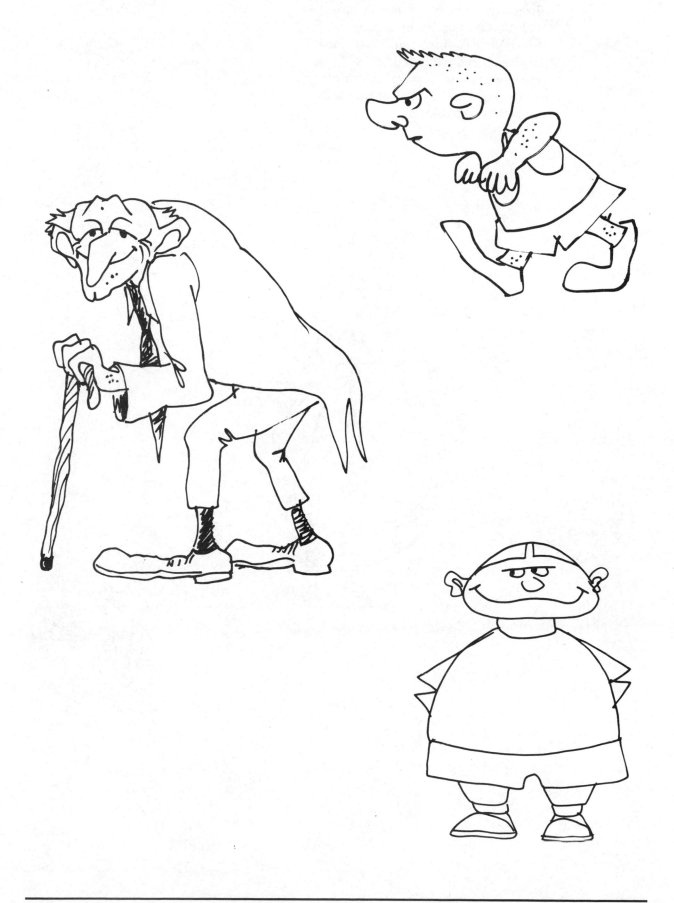

Take those "ideal" measurements, mix them with heavier and slimmer builds, and stir well with the cartooning principles (talk about your latitude and longitude), and we have endless variations to distort, warp, stretch, shrink, and generally fool around with the body's dimensions.

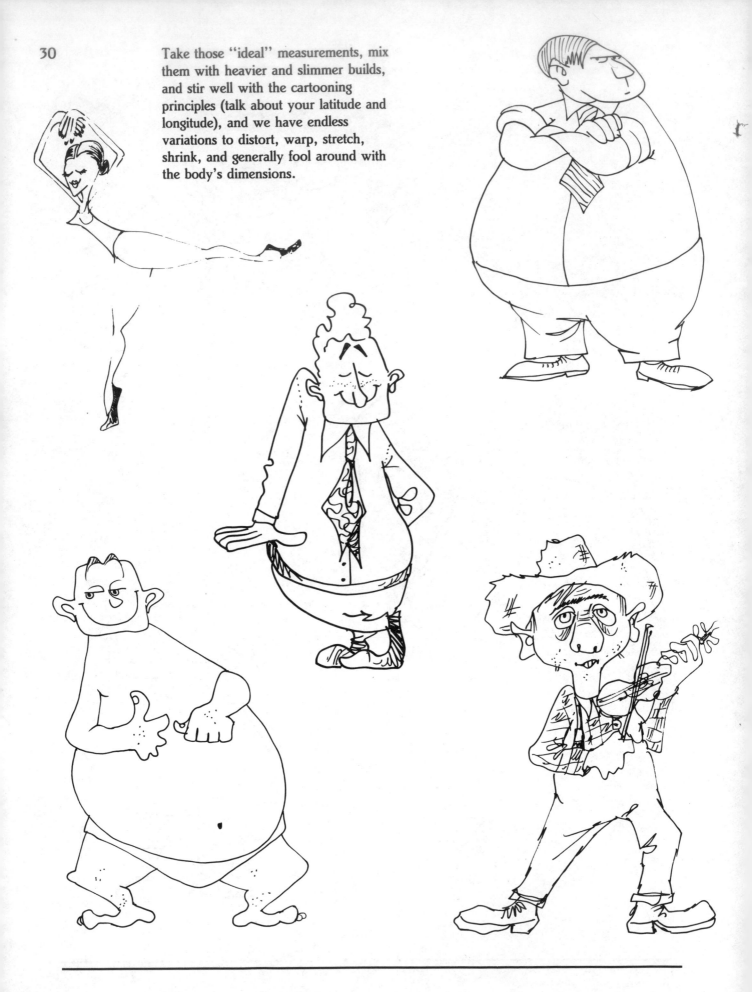

Also it's helpful in the beginning to utilize the good old "marionette" formula even with cartoons. It helps you to arrange the limbs in a way that still retains the basic, albeit distorted, version of the human form.

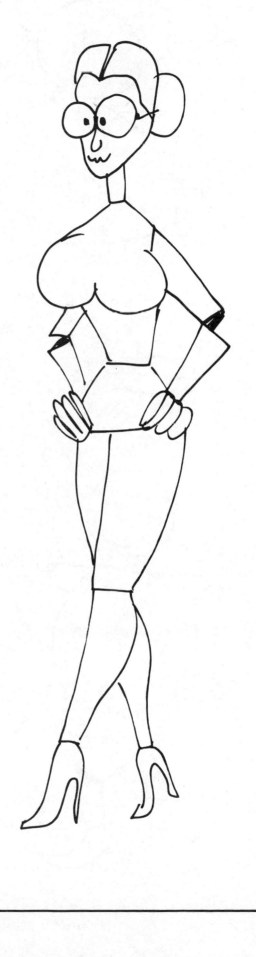

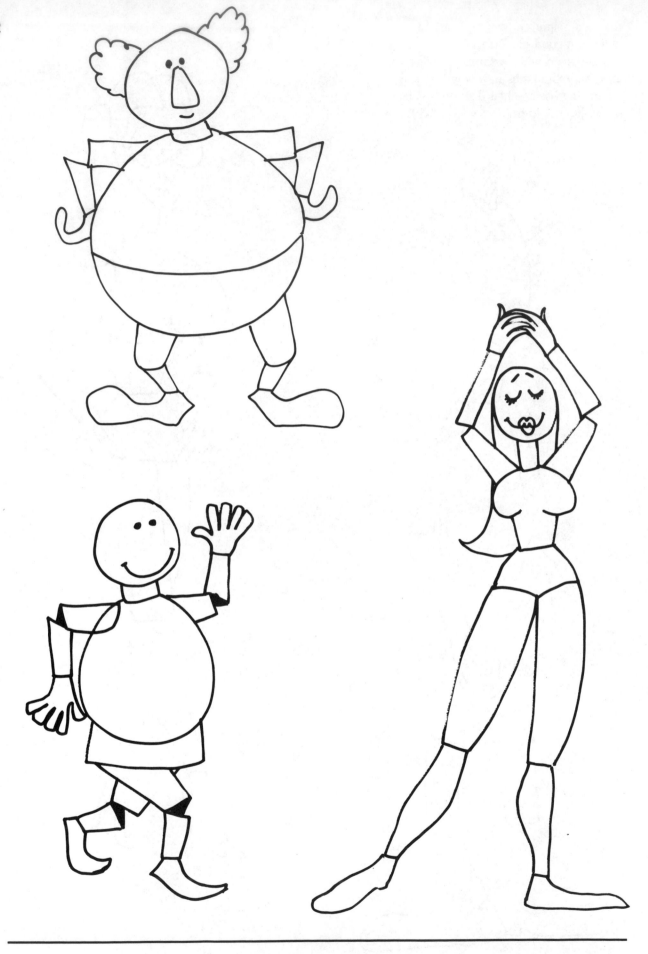

Often a good way to approach cartooning is to do almost a complete about-face with normal dimensions. That is, if the "ideal" female figure has long, willowy legs, high, firm breasts, small feet, and a tiny nose, merely concoct a new character totally unlike that one. To make a goofy-looking lady, give her a long nose, tiny mouth, sagging breasts, funny shapeless legs, oversized bunioned feet, a long thin neck and, to top it all off, too much hair for her little tiny head. But first let's do her in the marionette fashion, and then a more detailed drawing. . . .

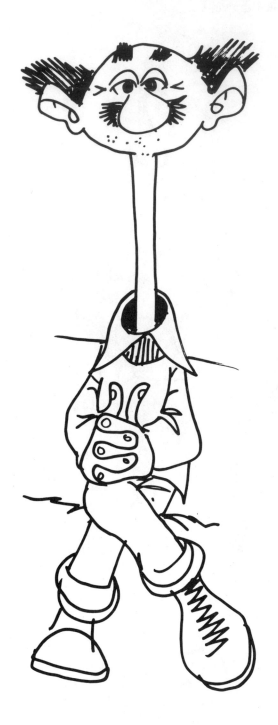

Oftentimes we may be tempted to go a little too far with cartoon distortion (a rather tempting trap but one that I encourage you not to fall into); if we stretch credulity too far, like certain unnamed motion picture plotlines, the viewer tends to lose interest. The creators have taken us just a step too far beyond the bounds of believability and lost us in the process. The same can happen with cartoons. To be safe, let's keep one foot in the realm of human dimension and the product will have more appeal and, I think, will ultimately be funnier. I remember seeing *The Wolf Man* when I was a kid, and when Lawrence Talbot was going through his metamorphosis, my innate sense of taste (be it bad or good) said, "Stop there! Don't go any further!" The transformation went too far for me. I thought the creature was more frightening with vestiges of a human face instead of crossing over the line into the "doggie" look. Anyway, my point is, don't go too far or you will lose that human touch. On these two pages are a few samples of distortion that I believe have been taken too far.

This guy's neck is too long, unless you want to make a specific point, i.e. that he's a snoopy reporter, a peeping tom, or a relative of a giraffe. Otherwise it's merely extreme distortion for its own sake.

The same applies to this guy's ears. Why? They're just too big and you immediately think of Dumbo but there was a purpose for large ears in that story.

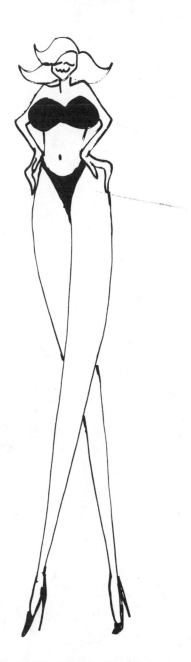

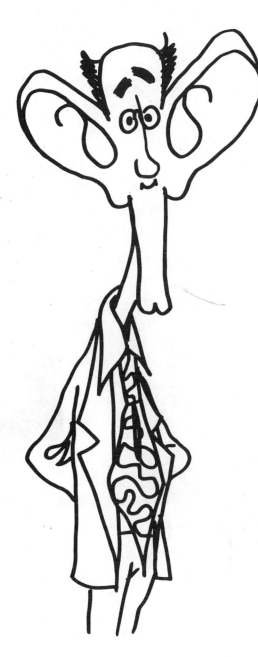

The same applies to this woman's legs. There's just too much of them. She becomes freaky as opposed to funny, more like a stilt walker than a human being.

Cartooning always poses a really interesting artistic challenge: to draw the human form quasi-proportionally correct while still maintaining a feeling of life below those layers of skin or clothing. This is not a simple task. It requires study, practice, constant application and, as I've mentioned before, lots of trial and (in my case, anyway) error.

The transformation of the human form into a cartoon figure is really only a matter of applying and controlling "uniform distortions," taking those basic principles and measurements and toying with them to achieve comic results. Instead of using the head measurement technique that we used earlier, let's go in a more abstract direction by using a series of shapes—a circle, an oval, a square, a rectangle, a triangle, a heart— and turn them all into cartoon creations.

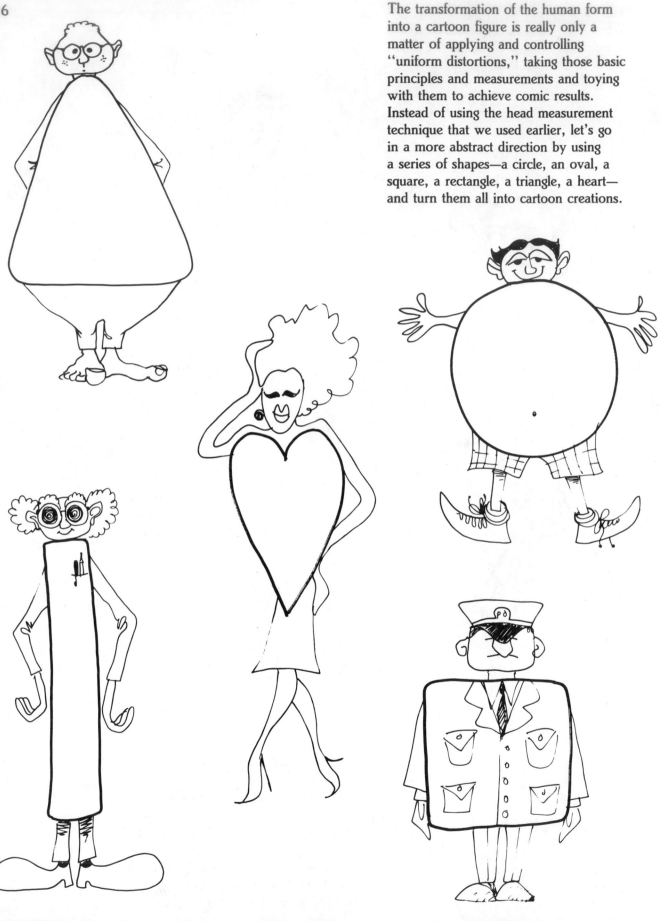

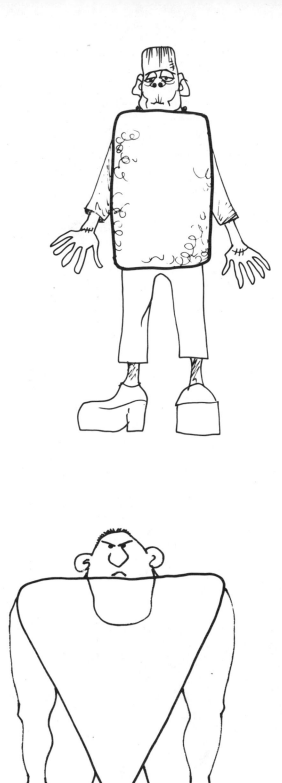

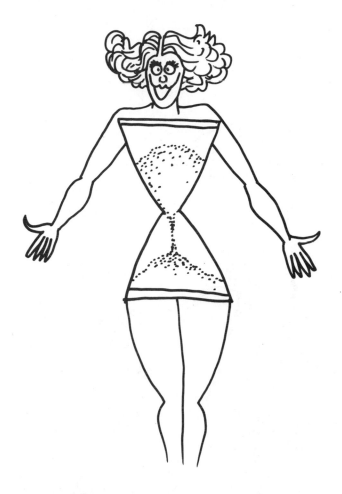

As you can see, the triangular-shaped body and the inverted triangle are merely slightly different versions of what we arrived at before: the muscular tough guy and the out-of-shape man.

There's an old joke about a girl with an "hourglass figure" (this evidently was the criterion by which women's bodies were measured in the 20s and 30s). The punchline went on to say, "But the sand's in the wrong end." I don't really know what that means since the ends are symmetrical, but again, here's a model we can use to establish the basis for a cartoon body. And you'll notice that it's not too dissimilar from the double triangles that we used earlier.

And these are only the tip of the proverbial iceberg. How about opening up our imaginations by using shapes that we're all familiar with, like fruit, for instance?

Here are some comedic bodies created from a banana, a pear, and a peanut:

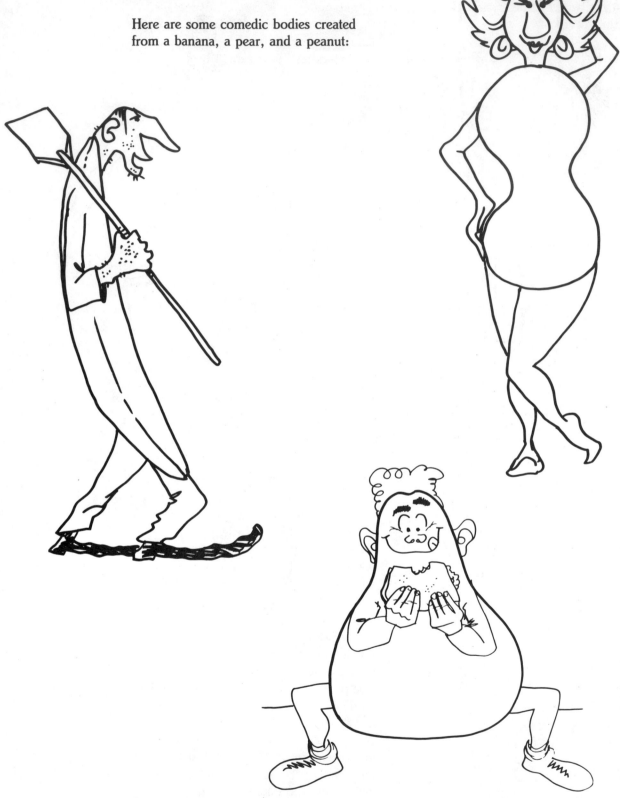

The point is that in cartooning, we have the lovely license to draw inspiration from a multitude of sources. Don't look only to the human body—the world is your oyster. In fact, while we're at it, what the heck, use an oyster. Or the world.

In the following chapters, as we begin to work on specific movements, first I'll demonstrate how to capture that particular action in a real sense, and then I'll move on to the exaggerated cartoon version of the same thing. So pay attention and be sure to keep your funnybone in working order. (It got that name because the bone is actually called the "humerus.") Amazing!

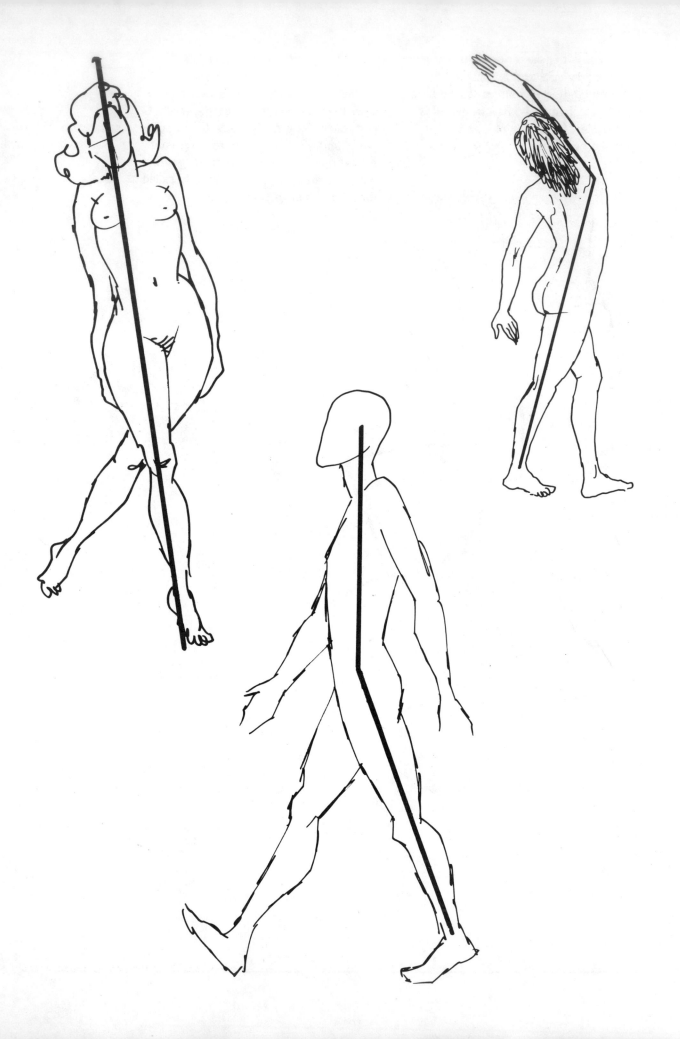

ACTION LINES

The action line is an imaginary line that
we draw through a figure to suggest the
thrust of movement in the body. It is
the key line that connotes direction and
pace. In extreme movement, the body
has to be slightly off balance to be
believable. On the other hand, we don't
want to draw figures that appear to be
falling off to the side uncontrollably
unless of course we're actually seeking
that effect, i.e., a figure losing his balance
on the edge of a ski slope. We always
want to feel, whether we are dealing
with a cartoon or not, that the body is
balanced and supported correctly, and
not in danger of committing some sort of
outrageous antigravitational behavior.
(Somewhere on the books there must be
a law against that.)

On the opposite page, I have drawn the
"action line" through a few figures.

Now you determine where the action
line is in these figures:

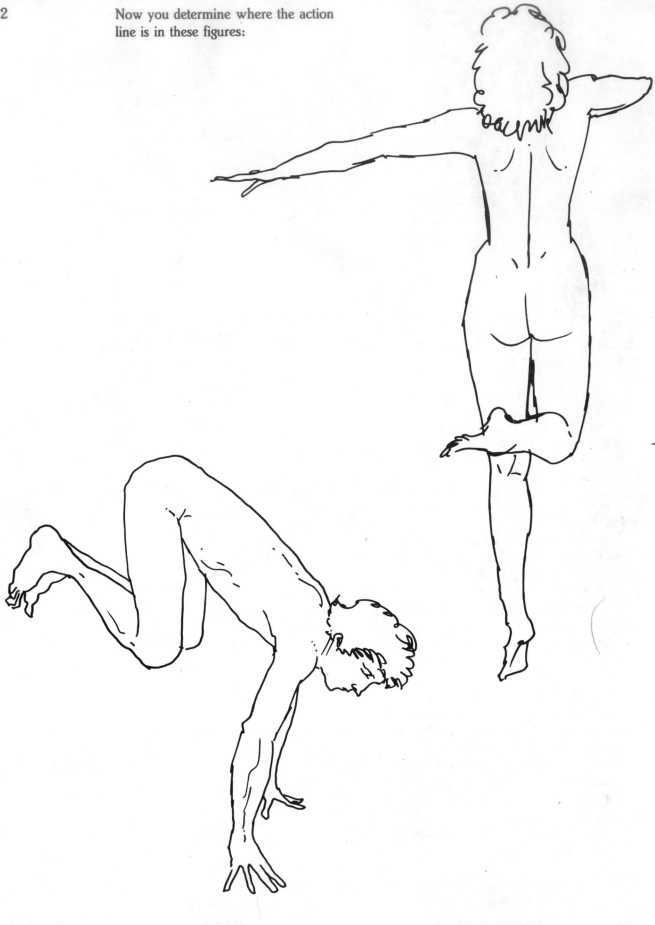

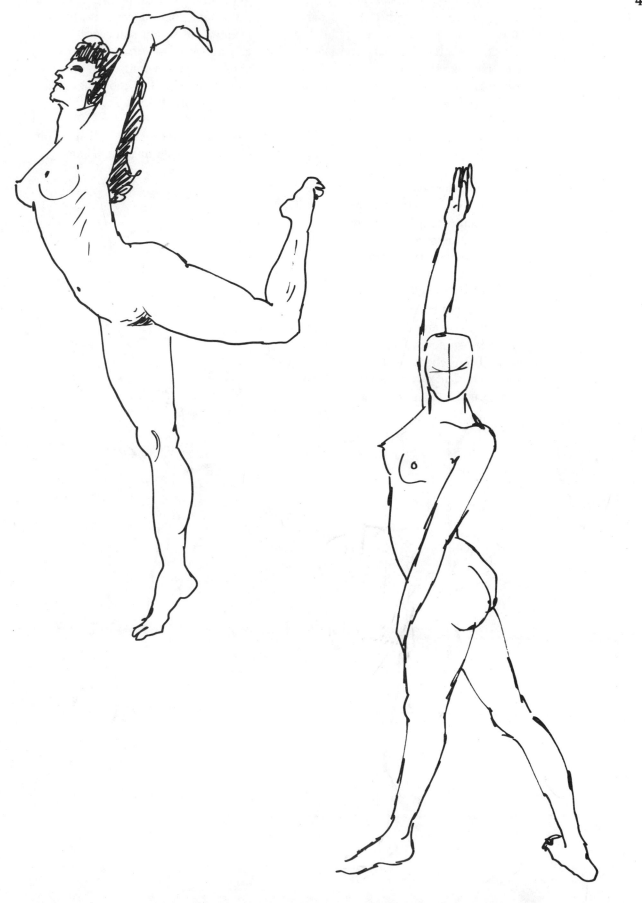

When you begin a drawing, sketch in the action line first, especially if your model is moving rapidly. There are certain poses that can only be caught with the camera's quick eye. It is your job as an artist to be able to record that feeling of speed and then later embellish and incorporate the body into that forceful line, the one that produces that incredible sense of motion.

The limbs, the waist, and the neck are the three basic movement areas. Gravity and muscular range are the only limitations imposed upon the human body. These are the considerations we must be aware of as we prepare a drawing. Our bodies are constantly in the process of counterbalancing: When we walk, one arm swings forward as the opposite leg moves back, and then vice versa. Even when we stand, our shoulders slant down in one direction while our hips slant up in another.

When both feet are planted firmly on the ground, our weight is distributed evenly, and so our shoulders level out accordingly. The torso tilts depending upon how much weight and force is being exerted at that moment on that portion of the body.

And the weight must be balanced on either side of an imaginary line.

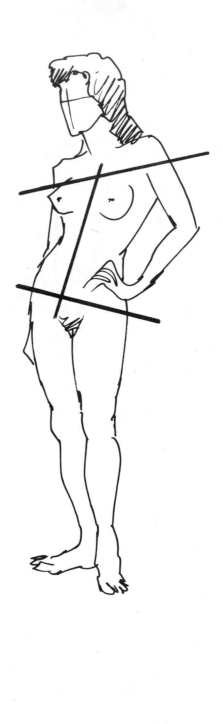

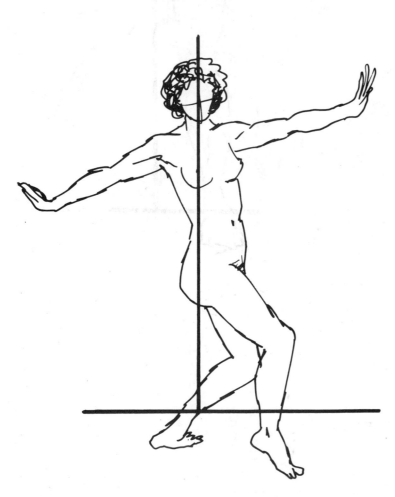

However, if not distributed evenly, the weight falls to one leg and the nonsupporting leg usually moves away for balance and comfort. We want to feel the major distribution of weight on the supporting leg.

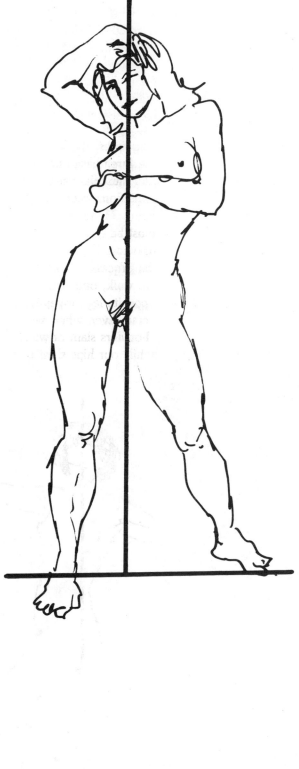

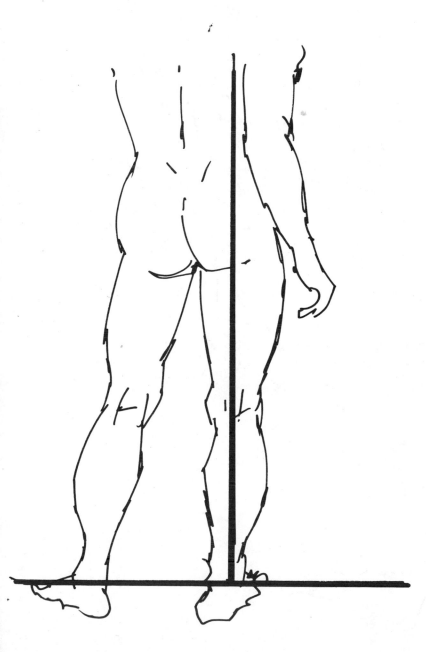

Keep in mind that legs can move forward twice as far as they can move backward, while arms have an extremely wide range of motion. Feet have considerable restrictions—they move side to side only slightly. Observe your own. The mobility of the waist is the most limited, but again, based upon individual capability: There are those lucky souls who are so pliable and nimble that they can not only touch their toes (I can only do it with the help of an outside crew and some John Deere equipment), but bend like a hairpin and press their palms to the floor.

So in trying to capture those series of contractions and expansions that we call movement—to sit, to rest, to jump, whatever—please remember that there's usually a good or interesting reason behind it. Movement for movement's sake (exercise is the only example this writer can come up with) is not the domain of the artist. It's too confusing for the graphic arts and requires too much explanation.

The action that you decide to capture on canvas or in your sketchbook is entirely your artistic choice to make, much like a writer or director deciding upon the placement of the camera or the point of attack of a scene. It could be the moment leading up to a fight, the fight itself, or the aftermath. You must make the same choice of the three points of action: preparation, the actual movement, or the follow-through. The illustration below is an example of the follow-through.

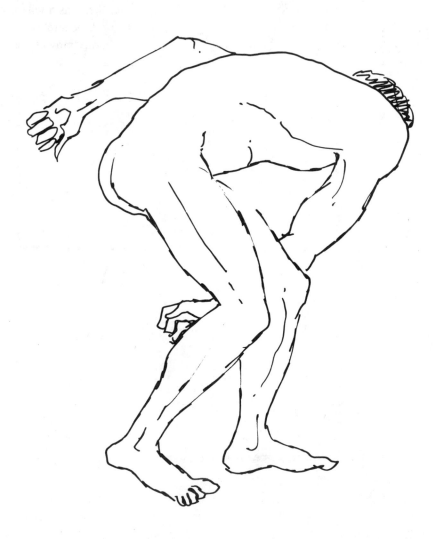

Always ask yourself not only what is the character and age of the person pictured but also, what is the emotional thrust of the action. Be it a teenage girl warming up for a dance audition for the school play, or an overweight man falling out of his hammock because of the sudden presence of an inquisitive bee, each one has to be handled differently. Don't make the mistake of rendering great agility to a person who appears incapable of it. The real name of the game here is experimentation and trial and error. Maybe even go so far as to make rough sketches of different versions of the same idea. The preparation, the movement or, who knows, maybe in this case the aftermath is more dramatic or visually arresting as a drawing. These are the personal, hence artistic, choices that separate you from other artists. Of course that's just one of myriad variables that helps you shape your own individual style. And that, after all, is what art is all about . . . your own very personal expression.

As we step once again into the realm of cartoons, let me remind you that the same rules apply. When it comes to balance and countermovement, cartoons are not exempt. The cartoon figure is capable of far more outrageous and gravity-defying (or would it be "-ignoring"?) conduct, but they still have to be based in quasi-reality.

Some cartoon figures do things of which the human body is totally incapable, but still we go along with it. They don't strain credulity so much that they lose our interest. When I was a boy there was a comic book that I was inordinately fond of entitled *Plastic Man,* and this unique superhero had a body that could metamorphose into all kinds of things: His arm could stretch for a whole city block to nab a fleeing criminal, or he could reshape himself instantaneously into a fire plug to escape detection. But that was a wild and amusing exception to our general rule. Cartoon bodies can do anything regular humans can do, and then some . . . but within reason.

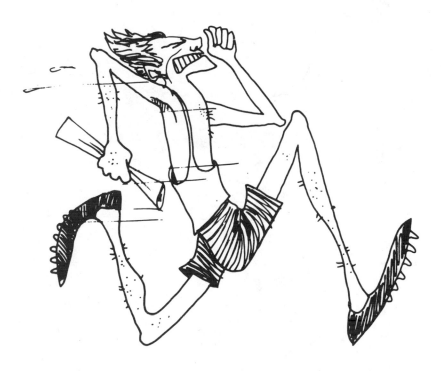

48 Here are a series of cartoon characters involved in strenuous activities, just to demonstrate that cartoons are not exempt from the action-line rules. Find their action lines.

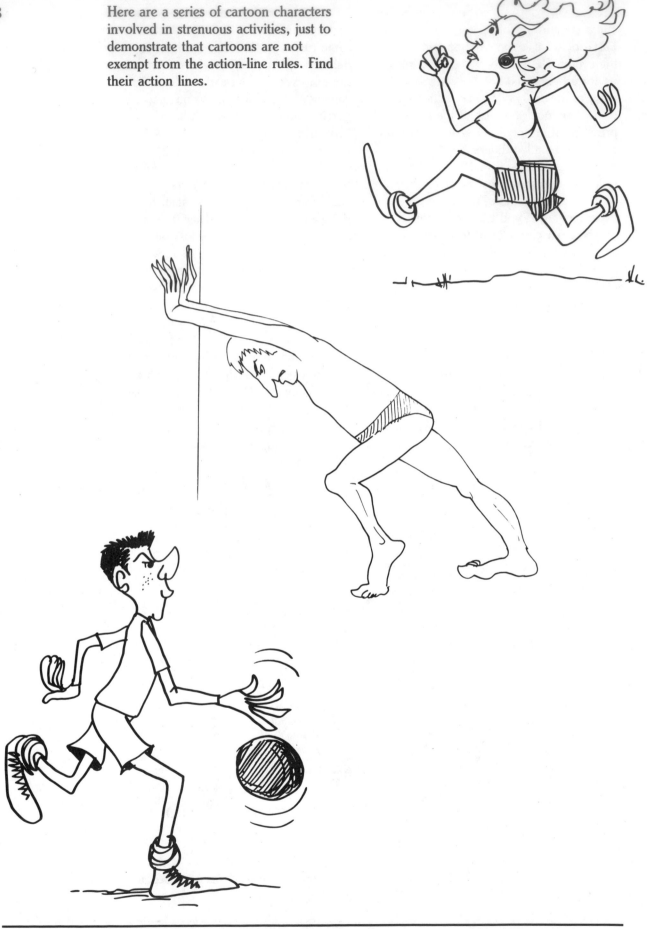

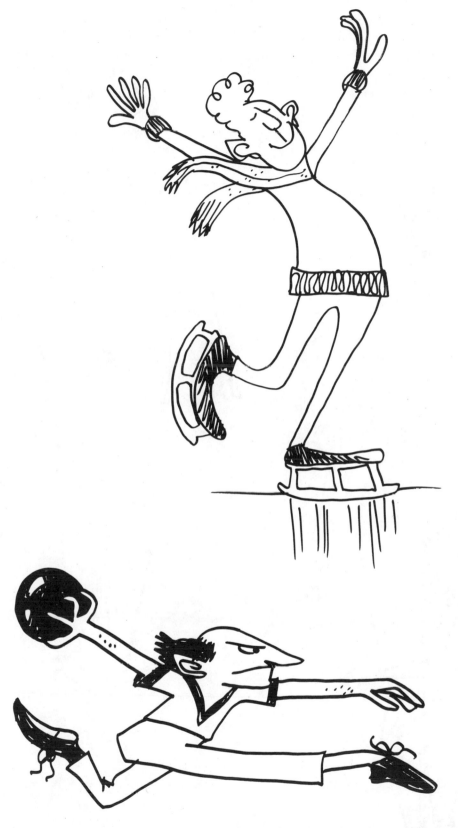

As you continue through the remainder of this book, keep a wary eye on that hidden action line and sketch it in your mind. Or really draw it in—what the heck, it's your book. Grab your pencil and go for it.

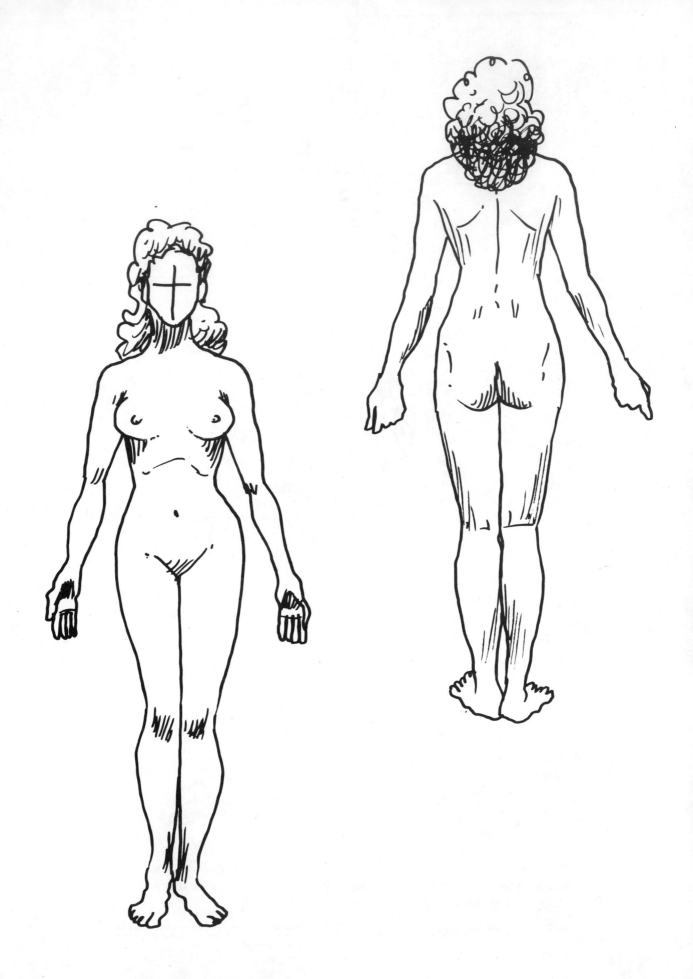

STANDING

In this chapter we'll approach a fairly static movement—standing, and acquaint you with what occurs when the human body participates in this comparatively nonstrenuous activity. Standing, like other movements, is never accomplished in just one way.

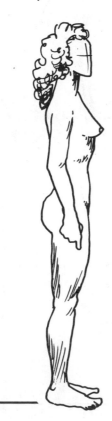

We shift our weight from one foot to
the other . . .

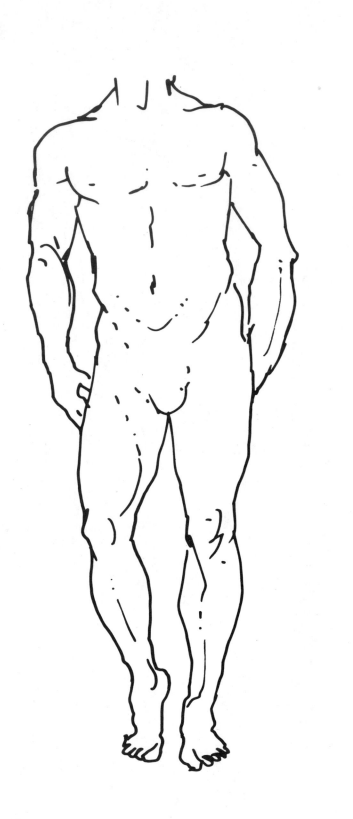
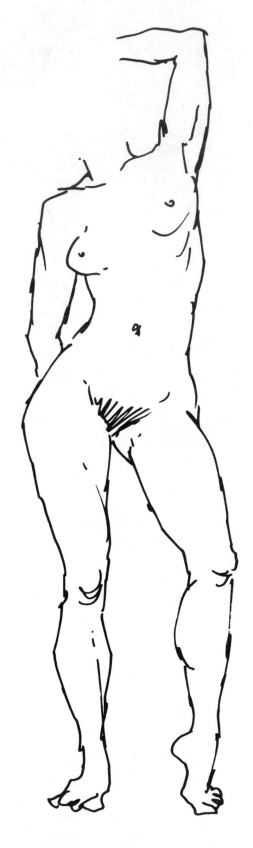

or we cross our arms.

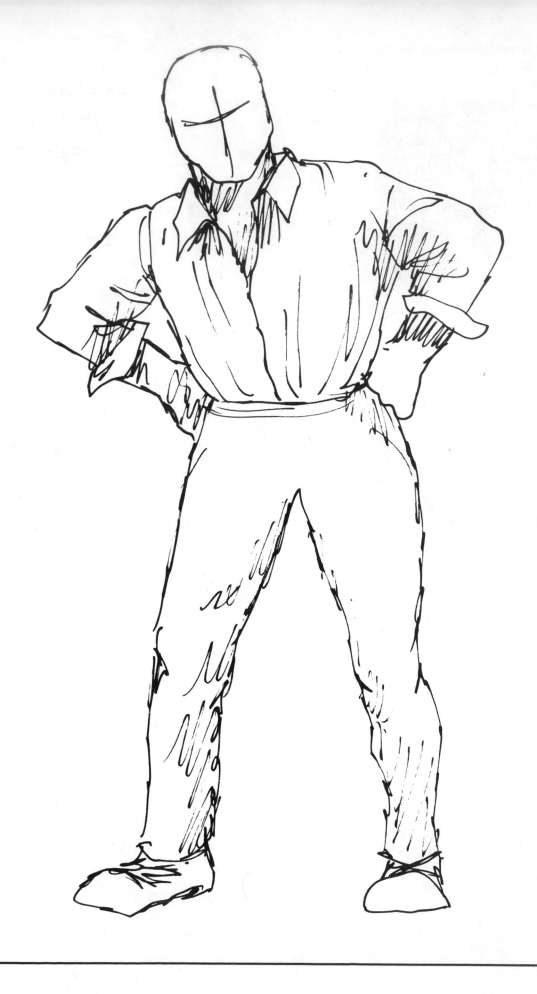

We should think of the human body not just as a whole, but rather as separate pieces influencing and pulling and pushing against each other while making up the whole. We call this poise or balance, and we should project that in the standing figure. Body language is so important in our society. For instance, what does the body on the left suggest to you? Truculence? Anger? No matter how you label it, it seems to communicate a combative attitude, legs spread apart, ready for action.

However, if we were to soften the position by bending one knee and dropping one arm to the side, it seems to say "impatience," as though the legs can't deal with being ramrod straight for very long. The figure on the right is relaxed as it waits . . . endlessly . . . for something or someone.

I mention all this because I encourage you to become sensitive to the body's positions and attitudes and what they communicate. You never want to picture someone just standing unless you want to say "boredom," even "impatience" has its own quality.

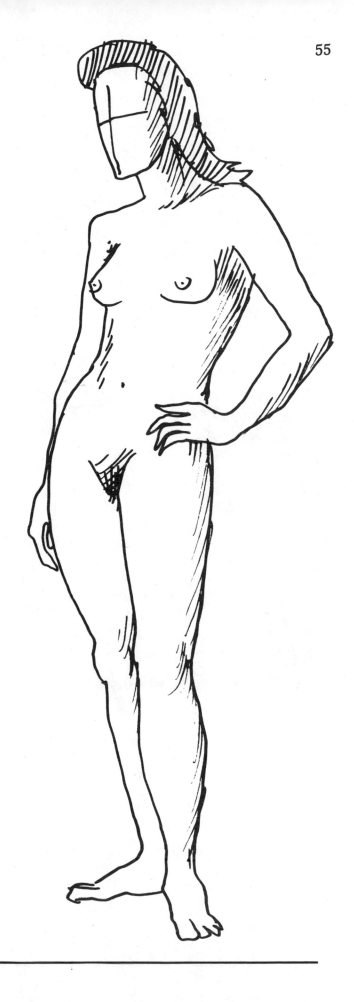

In these two poses the shoulders and
hips are fairly level with each other.

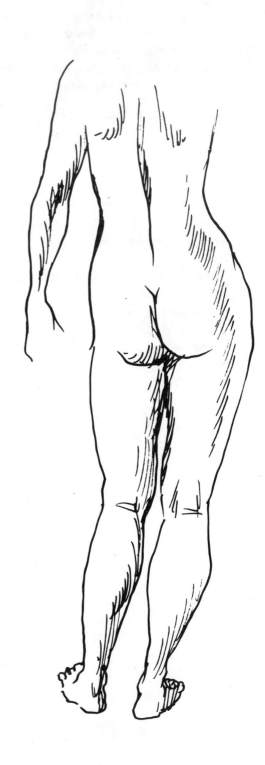

But notice as we radicalize the
movement, the angles of the shoulders
and hips become more acute.

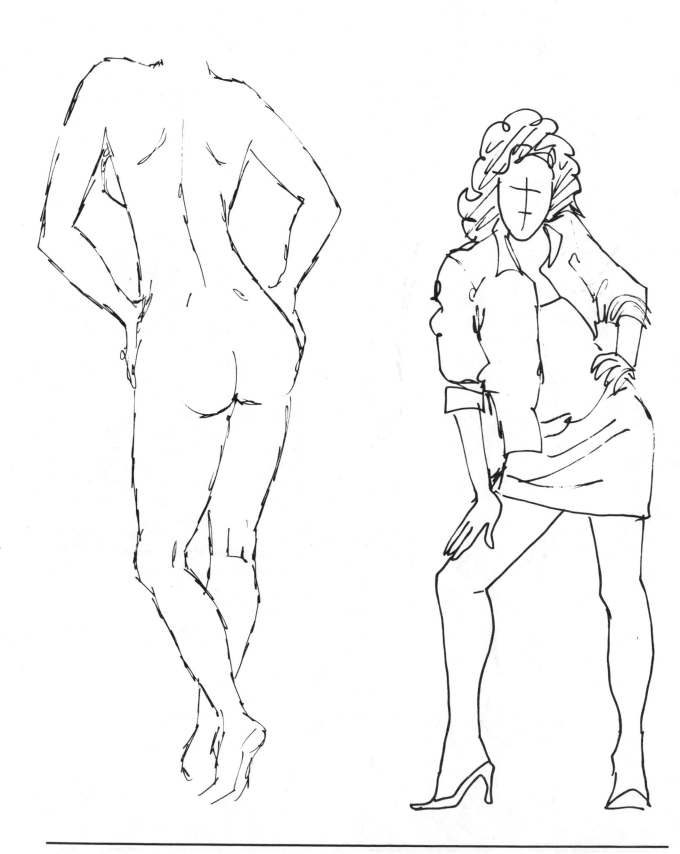

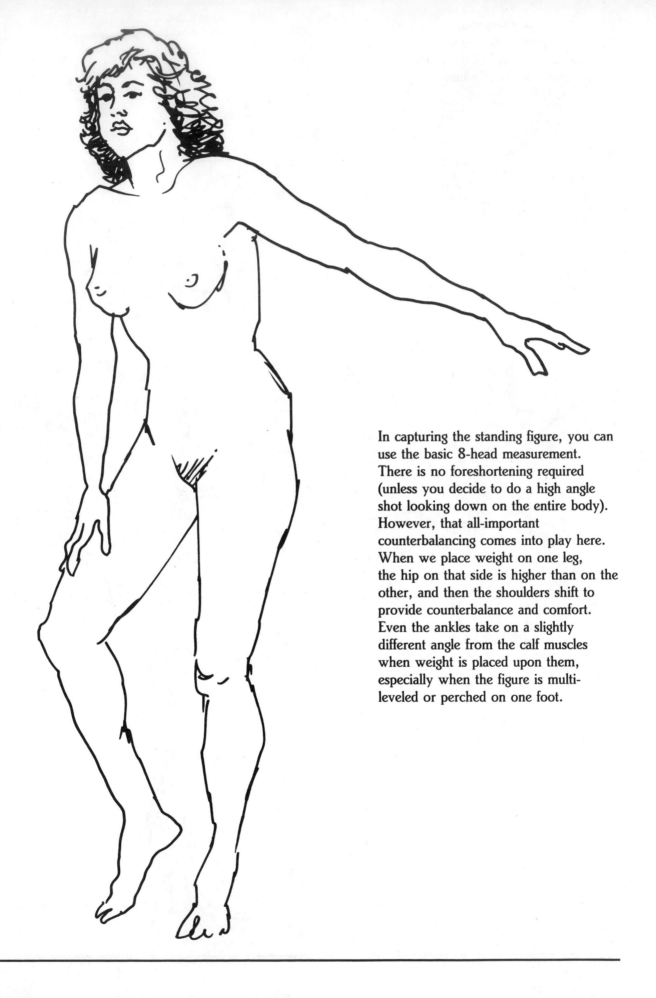

In capturing the standing figure, you can use the basic 8-head measurement. There is no foreshortening required (unless you decide to do a high angle shot looking down on the entire body). However, that all-important counterbalancing comes into play here. When we place weight on one leg, the hip on that side is higher than on the other, and then the shoulders shift to provide counterbalance and comfort. Even the ankles take on a slightly different angle from the calf muscles when weight is placed upon them, especially when the figure is multi-leveled or perched on one foot.

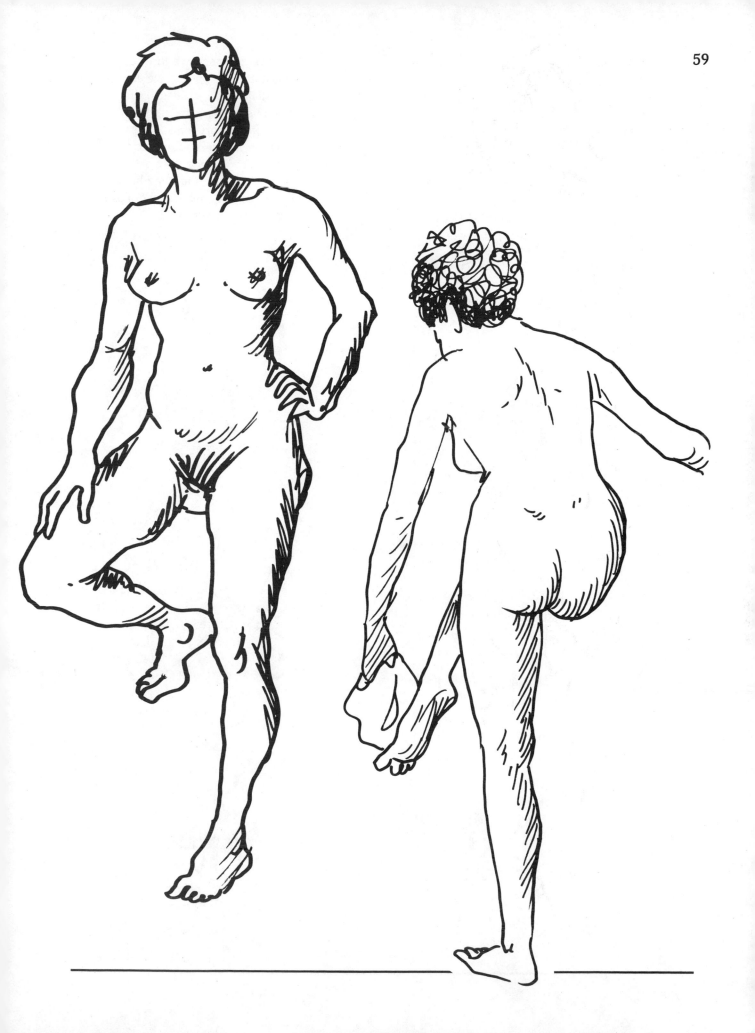

And of course when we turn to cartoons, everything that we've just said is immediately exaggerated tremendously. Here are most of the figures from the previous few pages redrawn as cartoons. Compare the angles; see how acute they become in order to emphasize the hyperbolic stance. Even the angles of the hips and shoulders are more radical.

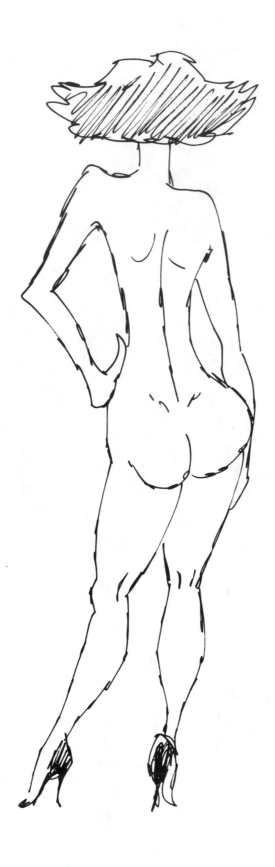

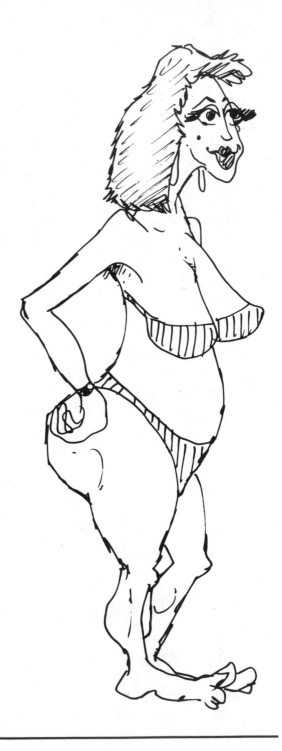

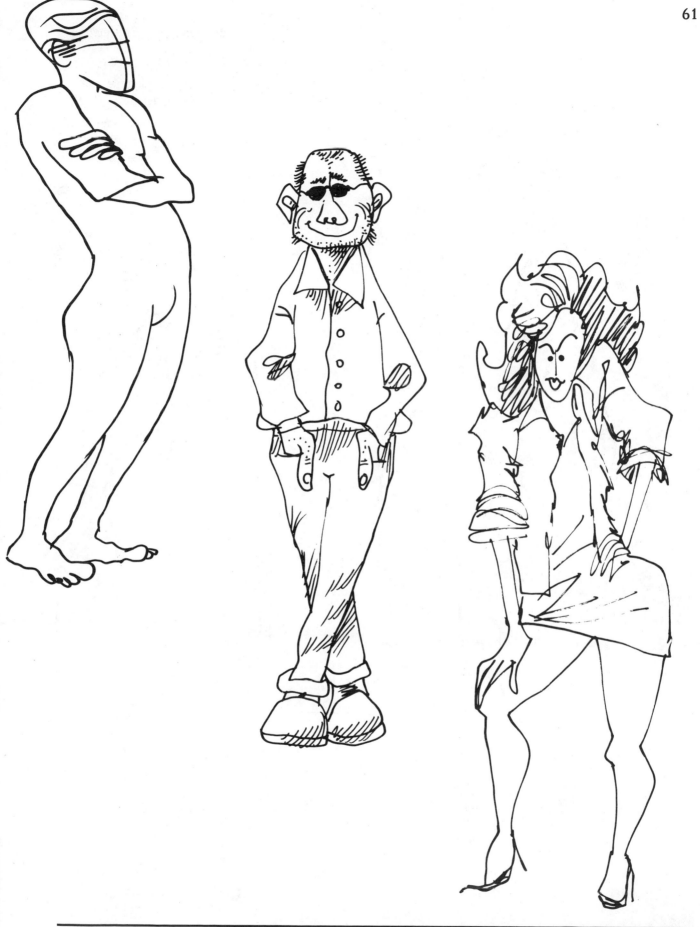

So keep your antennae sharpened and observe those around you. Become aware of the multitudinous stances that are out there just waiting to be drawn and recorded for your files, or (who knows!) maybe even for posterity.

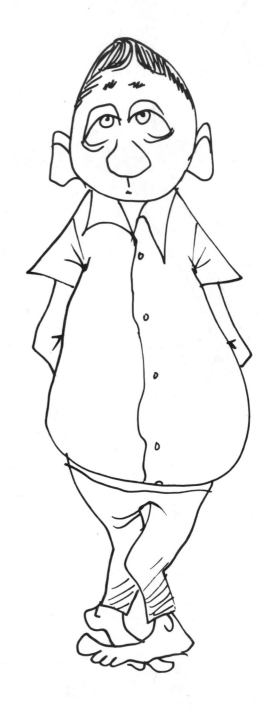

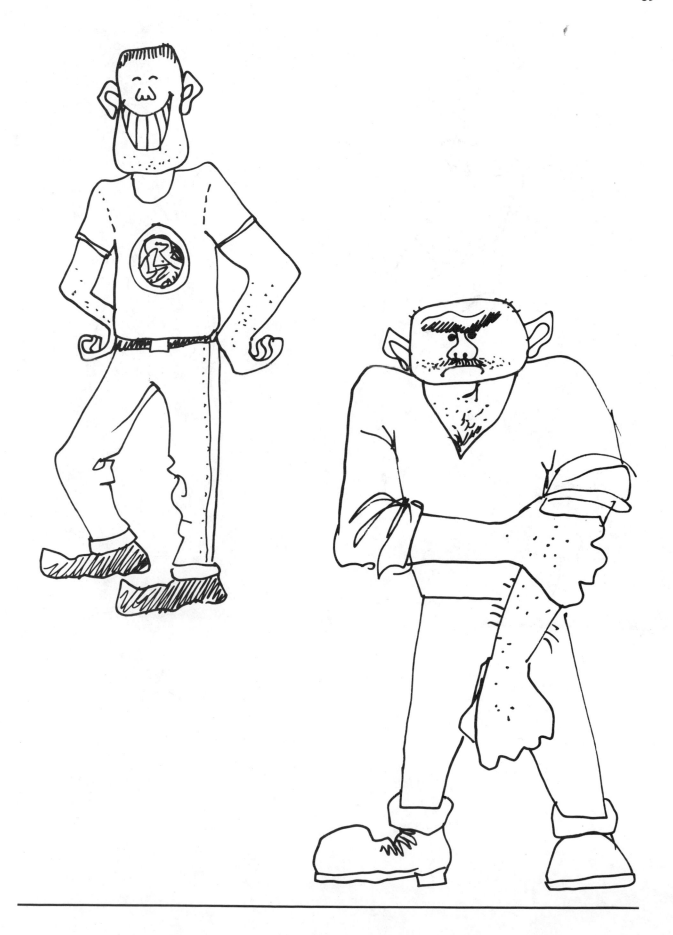

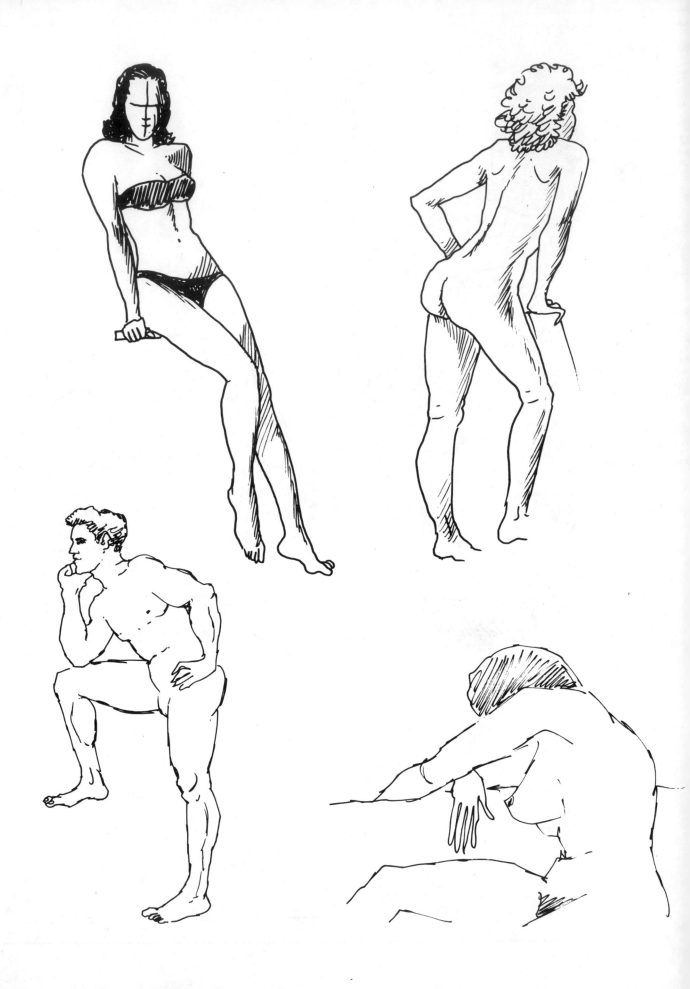

LEANING

Sometimes I think we're all basically lazy.
Rarely do we stand erect, shoulders back,
stomachs in, feet together. We like to
slump and slouch . . . and lean. Oh, how
we love to lean. We lean on each other
while we walk; we lean on chairs, on
buildings, on cars . . . like the tower in
Pisa, it seems we're constantly in the
act of leaning. So I felt it deserved a
chapter of its own.

When we draw leaning bodies, we want
to feel that weight pressing down, that
force being exerted. The triceps in the
arms usually bulge a bit to support
the added weight, and the legs are
somewhat lax. No matter what variation,
we should always feel that if we were to
remove the support, the figure would
indeed collapse.

Also note how it thrusts the shoulders
higher and causes the back to bend more
noticeably. The arm will often lock to
support the weight, and so it bends
backward slightly.

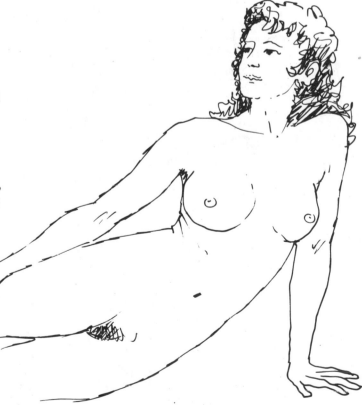

Or when a body leans to one side,
notice how the opposite leg shifts over
to provide a comfortable balance for the
body weight.

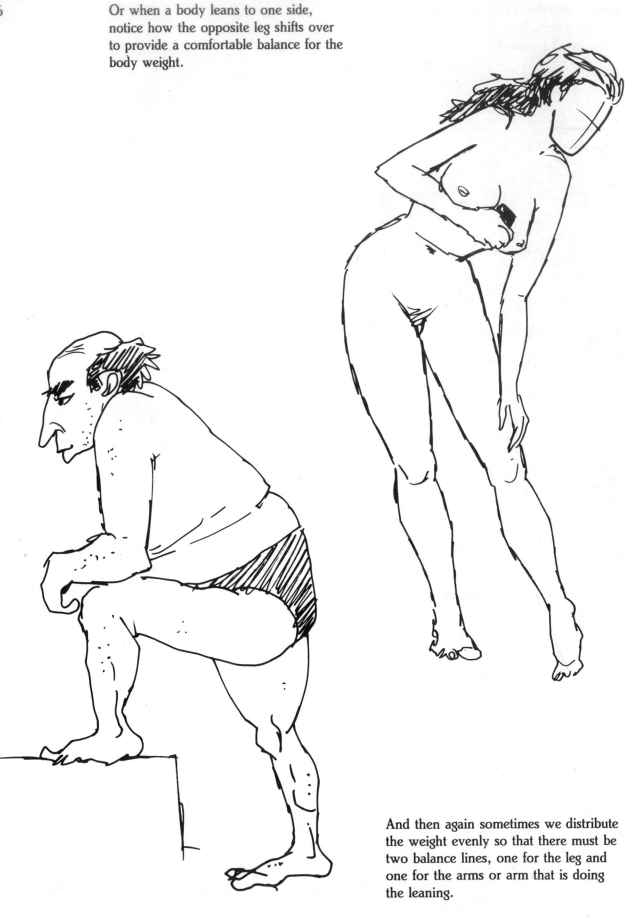

And then again sometimes we distribute
the weight evenly so that there must be
two balance lines, one for the leg and
one for the arms or arm that is doing
the leaning.

Here's another leaning pose, followed by
a cartoon version:

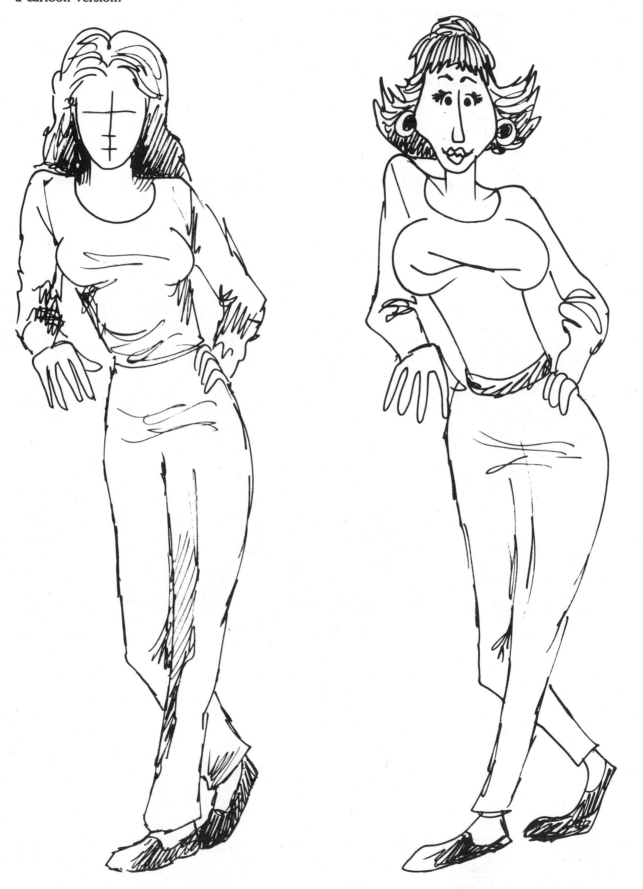

The figure that leans in the cartoon *really* leans. See how much higher the shoulders go, the hip shifts way out to the side, and one leg stretches farther out? However, still we must believe that it is possible for this body to stand there. We can't distort or play with balance so much that it appears this figure, cartoon or not, would collapse or would be unable to bear the weight of that extreme a pose.

We want to portray humorously (in a sense, satirize) the movements of the human body, not defy gravity or anatomical logic.

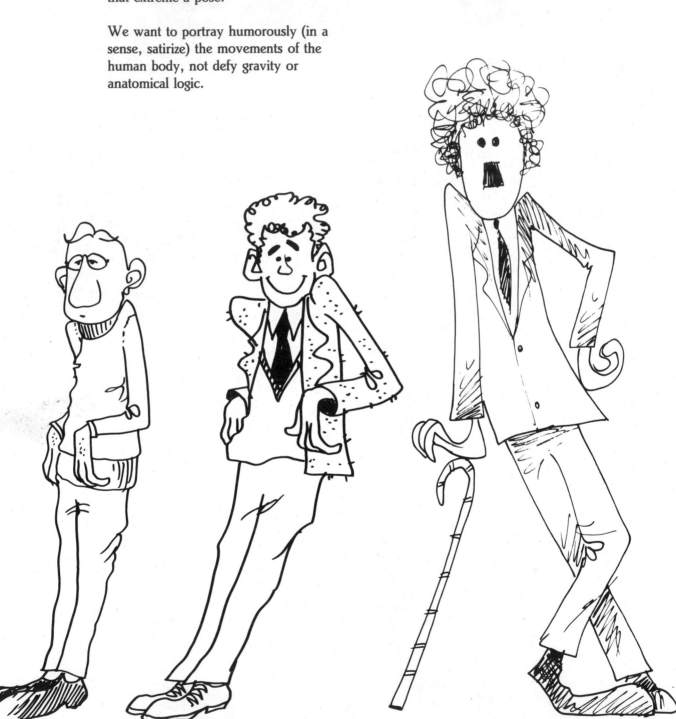

Here's a quick sketch I did of a man in
a pool hall doing an interesting thing:
leaning way over trying to sink the
elusive eight ball behind his back . . .

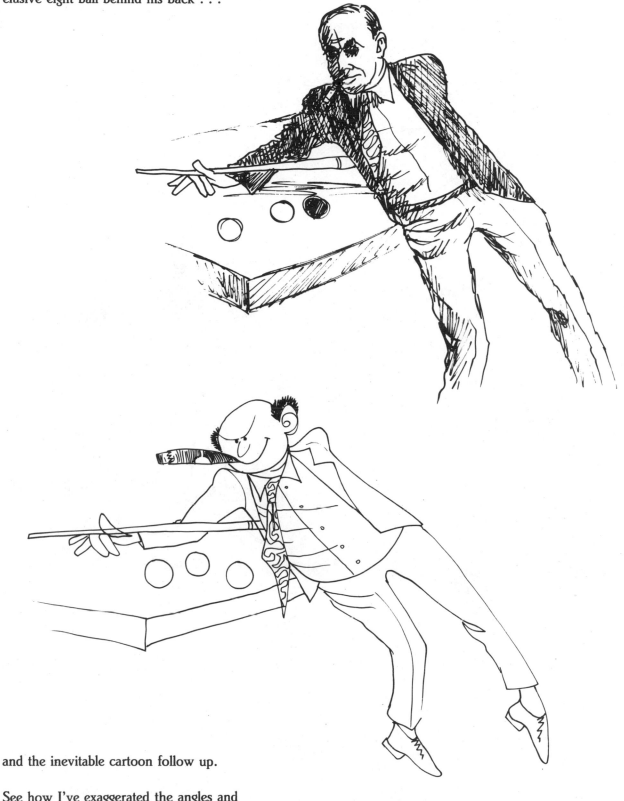

and the inevitable cartoon follow up.

See how I've exaggerated the angles and
his stretch so that he appears more
uncomfortable in the cartoon version?

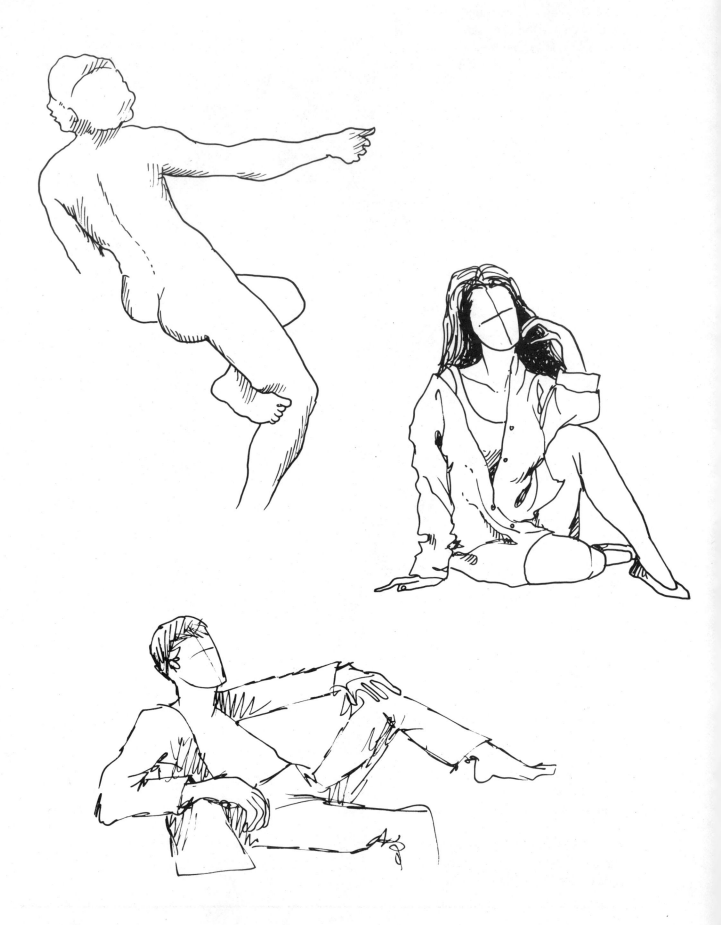

SITTING

Here's something we all do a lot of: sitting. We sit when we eat, talk, work at the computer, drive, certainly when we draw. We spend maybe a good third of our lives sitting. And like any other activity there's more than one way to sit. We never sit just one way: We slouch, we sprawl, we lounge, we straddle—rarely do we sit properly, even at the dinner table. So this chapter will deal with many variations on the basic sitting theme.

A lot of things happen to our bodies when we sit. Our thighs and buttocks flatten out from the weight pressing on them; our shoulders may be pushed upwards by our arms supporting our torso; our arms lock behind us as they're asked to support additional weight; and our stomachs protrude and/ or fold a little more (depending upon our excess avoirdupois or lack of it).

And when we sit we do all sorts of weird and interesting things: We twist our bodies around in outrageous positions; we pull our legs up close to our chests; tug at our feet; grab our arms; and bend our spines around as much as we possibly can.

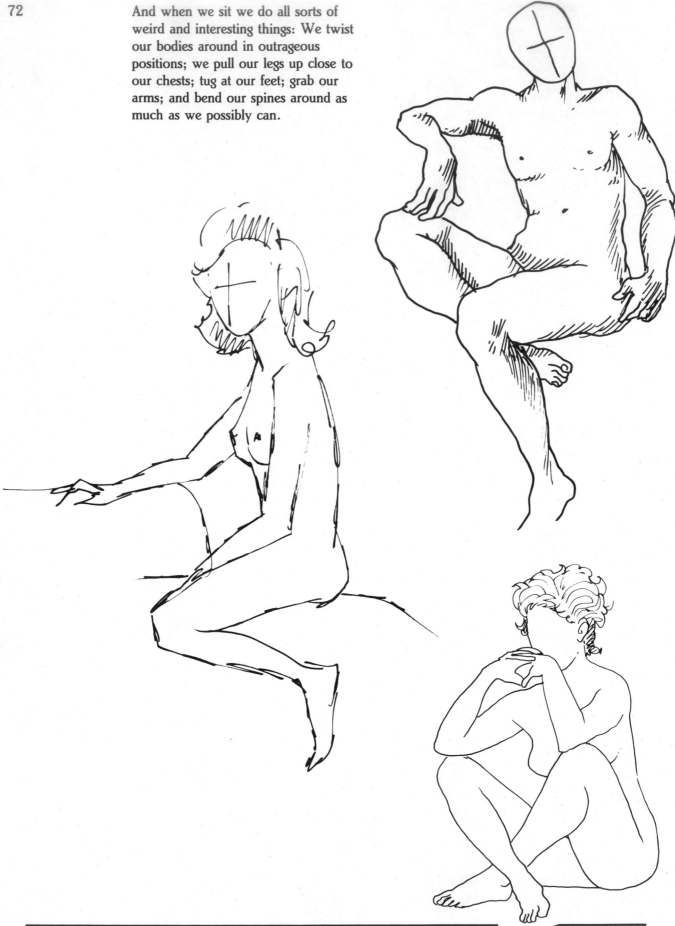

When we draw the seated figure we use the 6-head measurement to foreshorten the image, but if you want to capture a very long, lean figure, the proportion must change to 9 or 10 heads tall.

As the illustration on the right demonstrates, the seated figure is 4 heads tall from the top of the head to the bottom of the buttocks; the area from the top of the knee to the floor is $2\frac{1}{3}$ heads high; and from the back of the buttocks to the front of the knee measures $2\frac{1}{2}$ heads.

First of all, though, let's talk about what happens when we seat ourselves. Sitting on a chair or couch is different than sitting on a flat surface. When we sit on a chair, we place our feet beneath our body at a point necessary to maintain our balance so that we're not perched precariously on the edge. When we sit on the floor, grass, or whatever, we

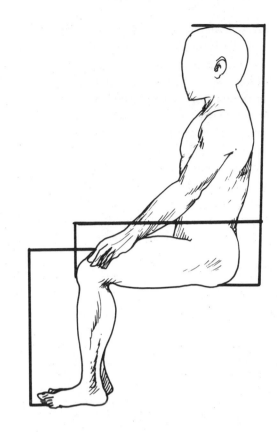

have a lot more latitude. We, the viewers, should be able to tell if the figure pictured is relaxed, tense, or expectant, for example, and that his weight is being supported by his legs, arms, and buttocks.

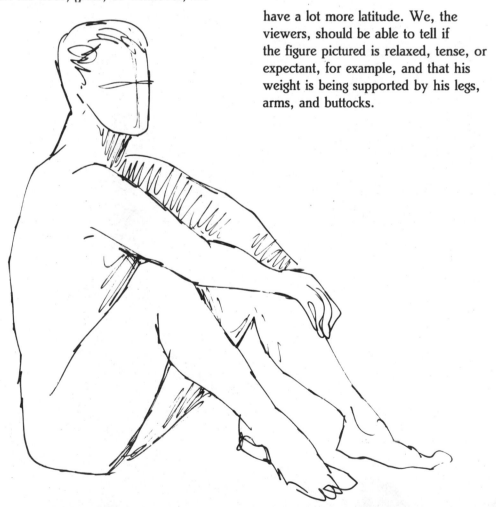

When you sit your spine curves slightly. You almost never sit ramrod-stiff unless you have the misfortune (like this writer) to have spent time in a military academy. For some reason, we seem to enjoy twisting ourselves around like so many living pretzels. However, when we twist our bodies around in seemingly uncomfortable positions, it does something to us. For instance, when we force our legs together, our muscles bulge out a bit farther, but our thighs flatten as well as our buttocks.

When we cartoon the seated figure, we simplify a great deal. We can suggest difficult foreshortening by overlapping some lines, and we don't have to acknowledge spinal restrictions. We can bend and loop the body around any way we want to (within reason, of course) to make our point. And again, with cartoons, as with all of this work, we want our figures to show some emotional expression. Is our figure sitting anxiously on the edge of his chair, or is he slouching back in a quasi-soporific state?

There are so many varieties of sitting poses (many more than 1,001, that's for sure), so look around you and observe humanity at its lazy best: lolling, draping, drooping, and record it for yourself in your little omnipresent (I hope) sketchbook. But do it in moderation. Too much of this will result in fatigue and the next thing you know, *you'll* be sitting down and then someone will be sketching you. And ad infinitum.

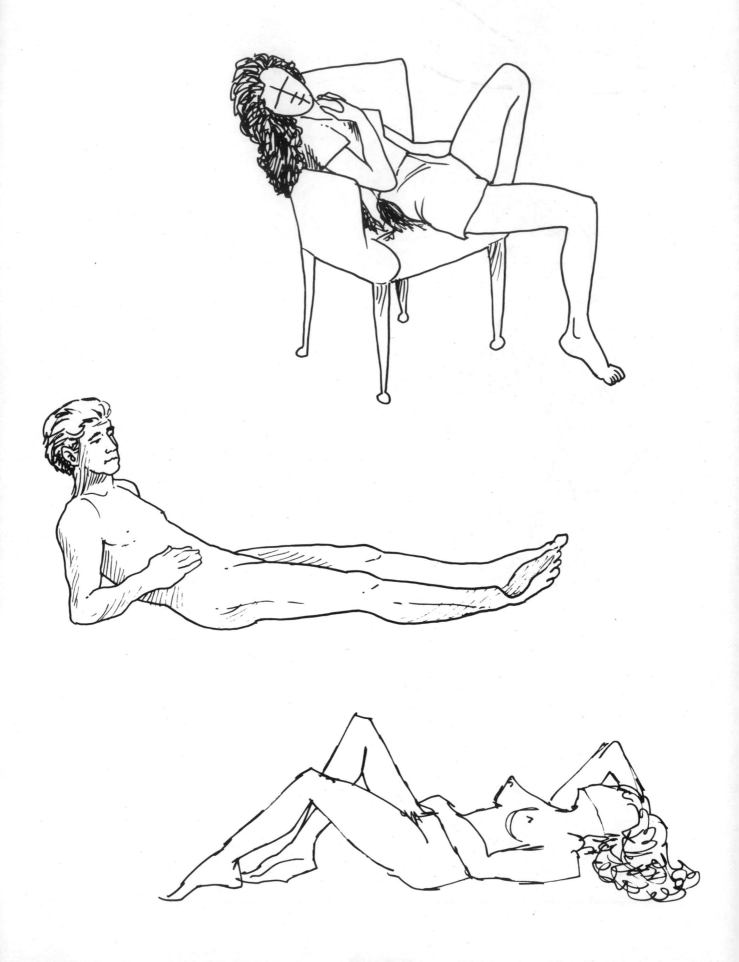

RECLINING

Reclining (I know it sounds pretentious, but "lying" gets confused with prevaricating and besides, "lying" not "laying," is a particularly sore grammatical spot with me), like sitting, is not accomplished merely by stretching flat on one's back and placing one's hands at one's sides in a coffin-ready pose. One can recline by propping up on an elbow, on one's stomach, knees bent or straight, arms behind the head or arms akimbo, hanging off the bed. Like all the other human activities we've discussed, there are myriad variations: exhausted, just relaxing, propped up watching TV, tense, restless, insomnia stricken, and the list goes on.

To draw the reclining figure, we return to the 7- or 8-head measurement concept. The need for foreshortening is almost nil unless you, the artist, place yourself at one extreme end of the figure or the other.

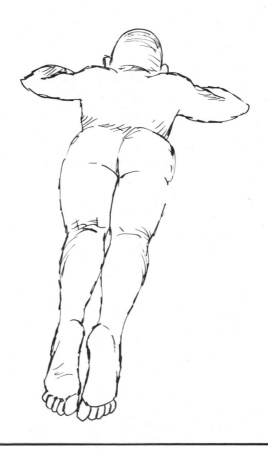

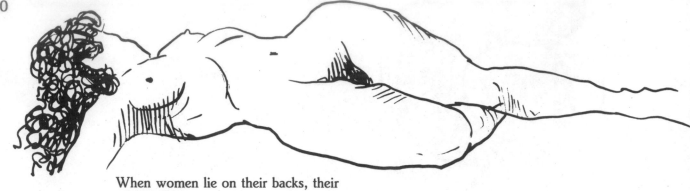

When women lie on their backs, their
breasts flatten out a bit.

When we lie face down, gravity pulls
our stomachs down to meet the floor.

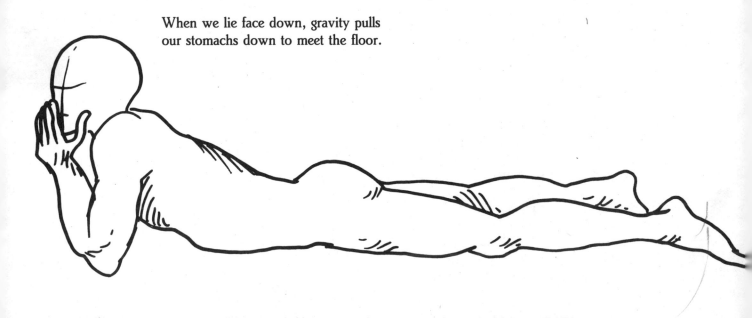

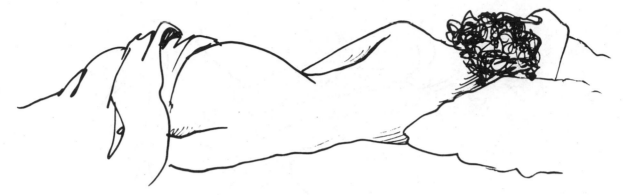

Also note how few strokes it takes to
capture a reclining figure . . . a rear
view . . .

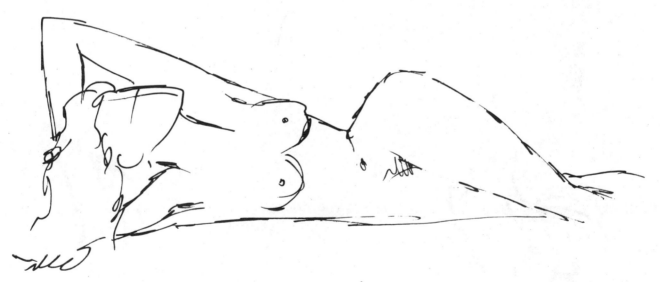

or a more glamorous pose.

And when we turn to the cartoon
versions, many of the same rules apply.

Observe how much we simplify and
exaggerate yet are able to maintain
basically the same anatomical standards.

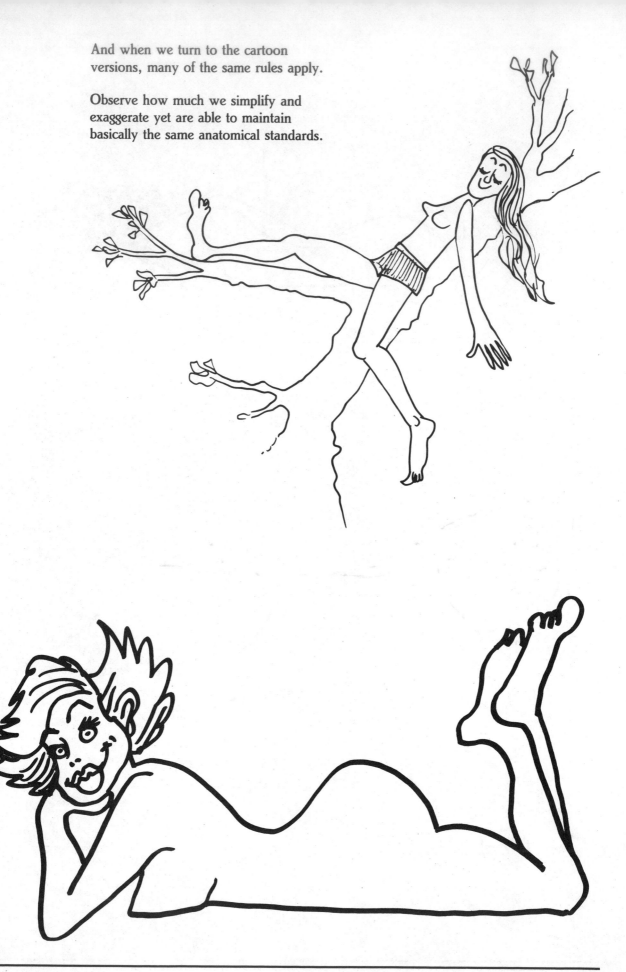

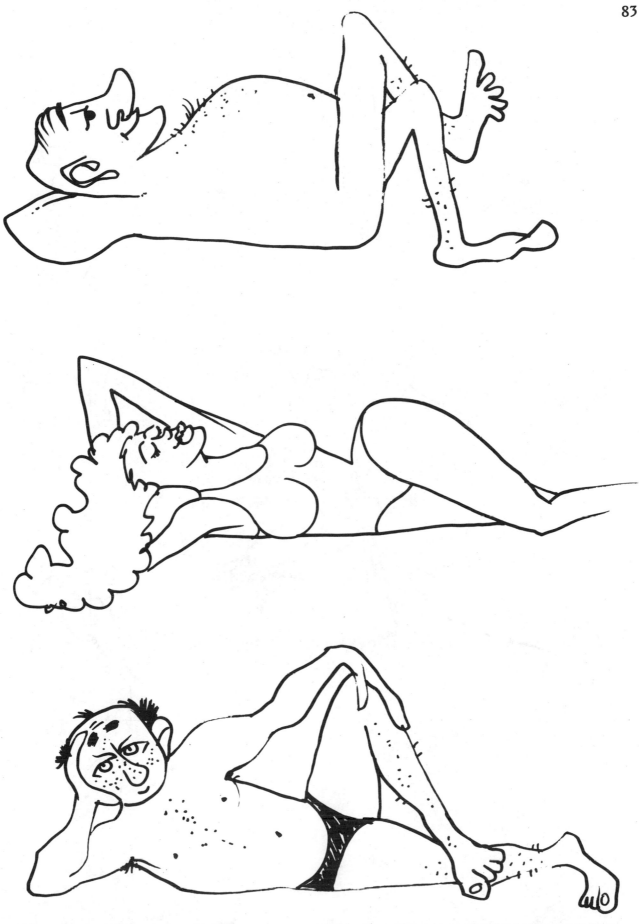

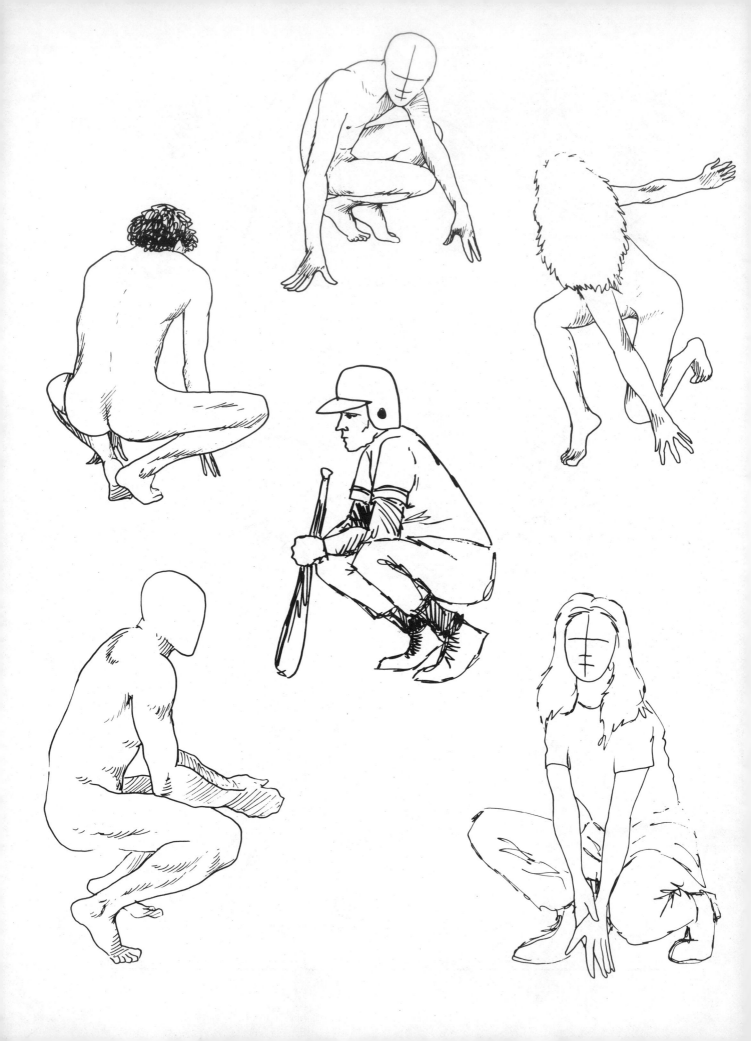

CROUCHING

Crouching, stooping, and squatting are activities that put unusual strain on the body so the muscles, especially those of the lower part of the legs, reflect the effort. Also, since these are difficult positions to maintain for long, there has to be a sense of expectancy in the figure.

When one crouches, the spine is curved to its utmost and the leg muscles are taxed so much that they bulge noticeably. The figure is balanced only temporarily, unless it's one of those flat-footed crouches that certain peoples from various parts of the world are comfortable holding for hours on end.

Let's take a few of these poses and transform them into cartoon characters, while being careful to hold on to the same stressful, off-balance feeling.

What tells you that the character on the right is expectant other than the grim expression? He is perched up on his toes to maintain his balance and his splayed fingers suggest extraordinary pressure or weight.

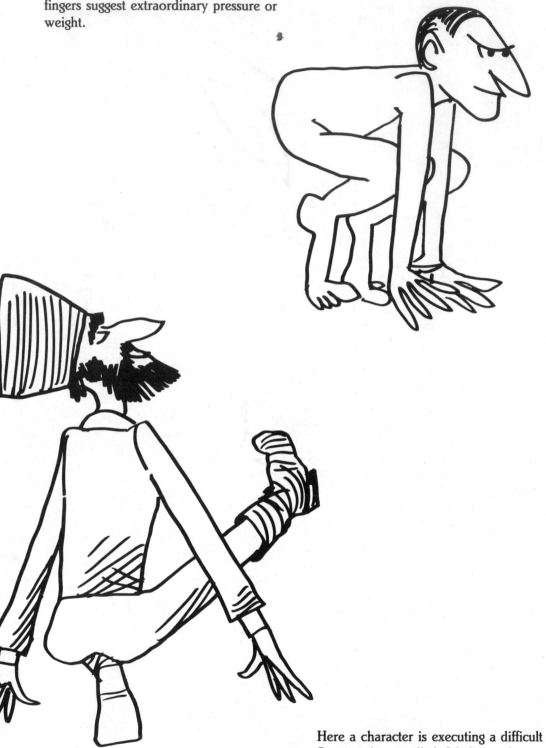

Here a character is executing a difficult Russian dance called, I believe, the "Kazotsky." See how his fingers are poised to help him, and how few lines it takes to suggest the bottom of that left boot?

In this sketch, we needed a bit of foreshortening in the right leg so we suggested the calf merely with the use of a small loop. But notice how the left shoulder is pushed higher because of the additional weight, and how the supporting leg's muscles bulge out.

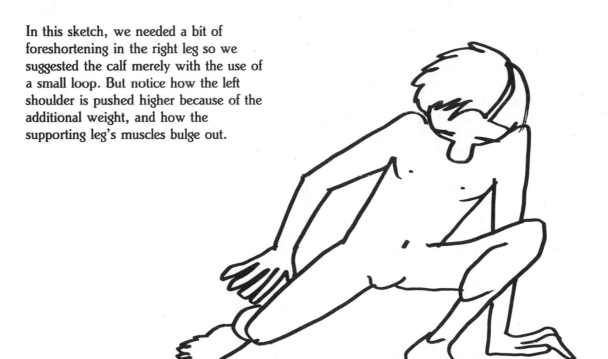

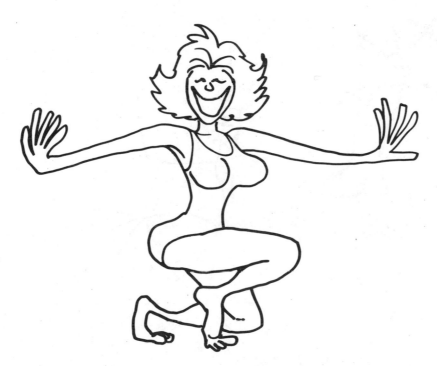

Even in this silly-looking dancer's pose, you still see her point of balance and the stress on her legs as shown by the bulge of her calf muscles.

Again, cartoons may be simplified and distorted versions of the human form but nevertheless they still must adhere to gravitational laws and physiological rules. Keep that in mind when you're drawing cartoons and the end product will be far superior. They will breathe with animated life and actually be more humorous, in my opinion.

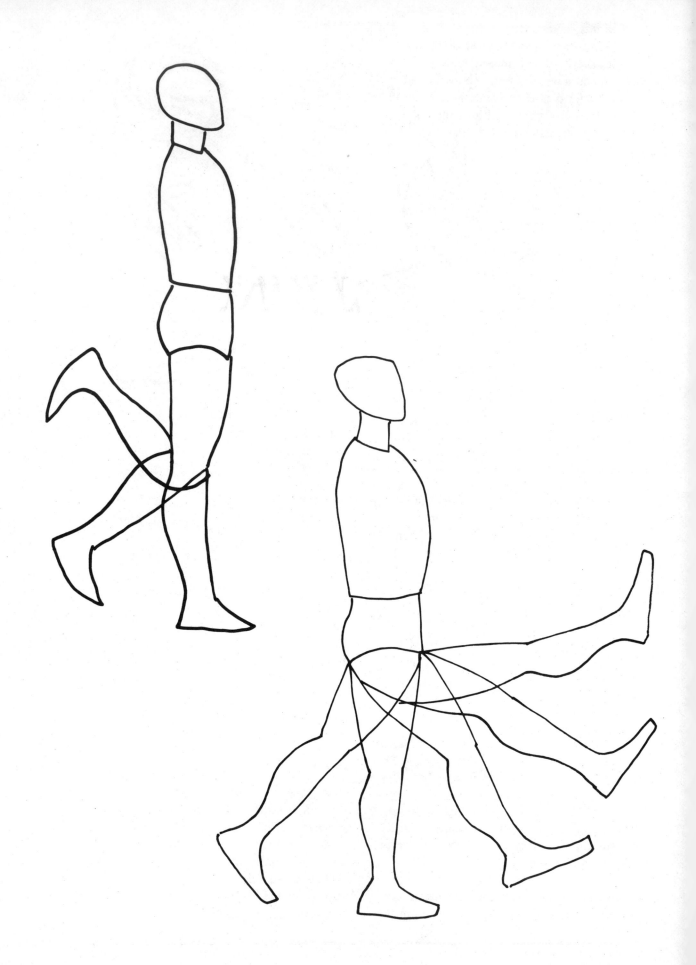

WALKING

Walking is one of those words that contains a multitude of interesting semantic offshoots, such as striding, ambling, moseying, pacing, clomping, mincing, waddling, or whatever. Then there is a subtle transition into running called jogging, and, as the pace quickens, it becomes actual running, sprinting, dashing, galloping, darting, trotting, tearing up the turf . . . pick a word or phrase that you like and then draw it.

We can usually determine which of these our characters are doing by the distance between the legs (the width of the stride); the expression on the face; the tilt of the body (is it leaning back casually or pressing ahead intently?); the angle of the arms; and whether the fists are clenched and pumping the air to help the legs, or the hands are hanging or flopping around loosely.

Let me remind you once again that the legs can move three times farther in front than they can behind.

It's important to capture that push off the back leg to project the feeling of motion.

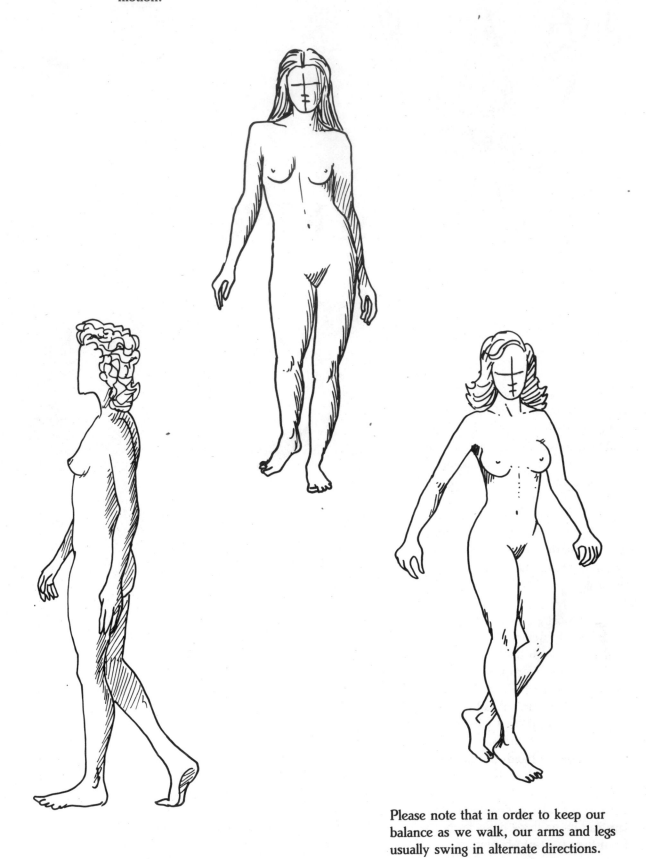

Please note that in order to keep our balance as we walk, our arms and legs usually swing in alternate directions.

We should be able to determine whether there's urgency or relaxation in the walk. Is the figure just loping along or rounding the bend at the finish line?

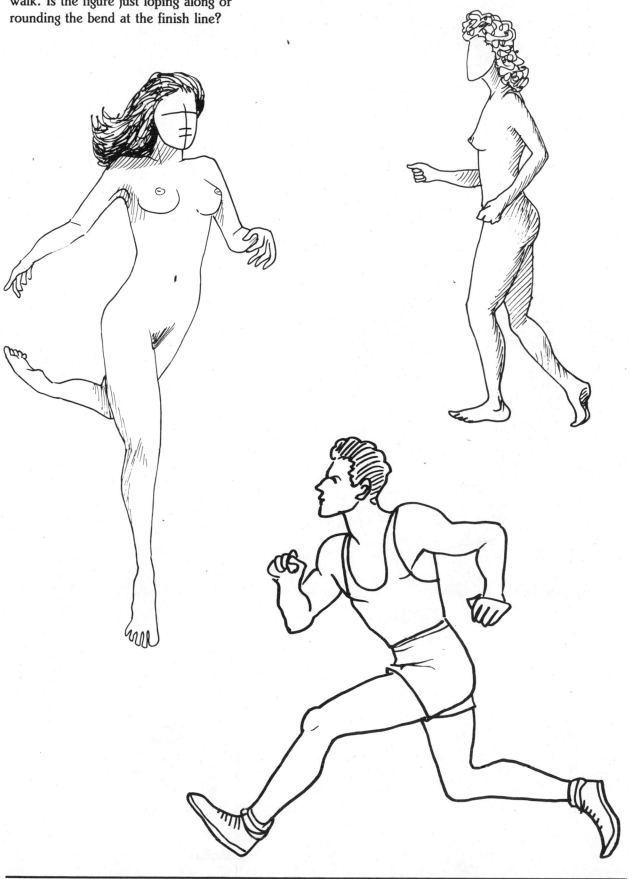

The cartoon figure has a wonderful time walking and running. His legs can move farther in both directions. Since he has less muscular restrictions, it's easier for us to exaggerate that particular movement, whether he casually ambles . . .

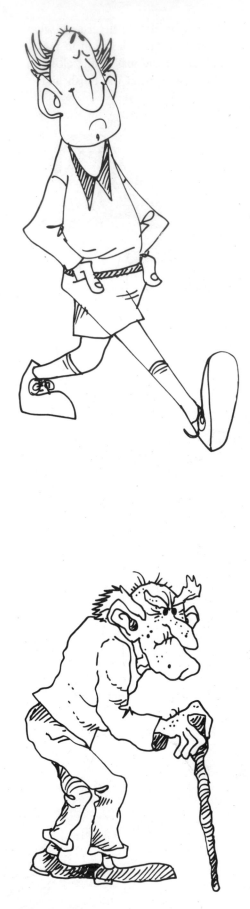

or walks briskly to work . . .

or shuffles cautiously . . .

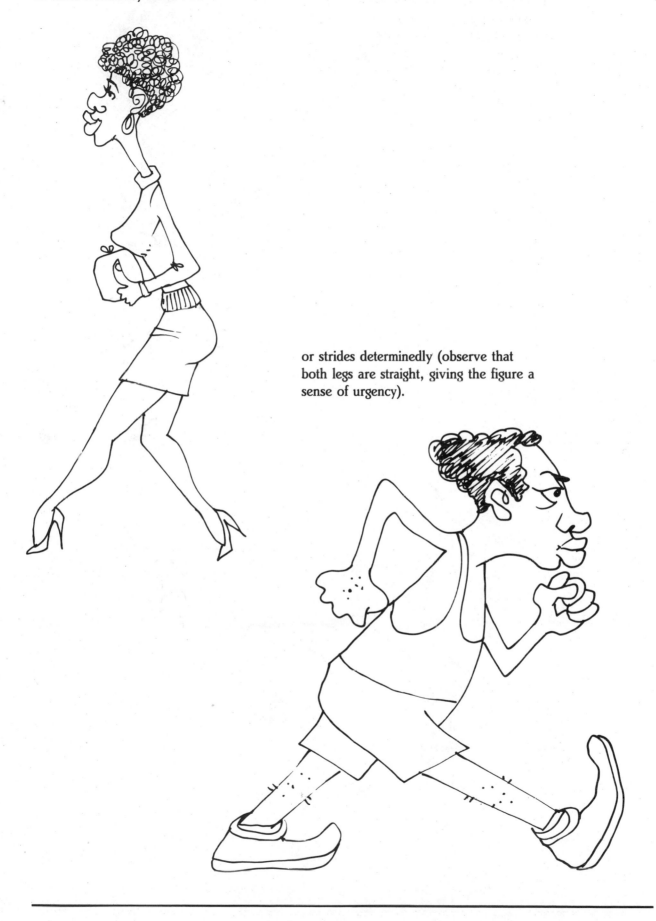

or strides determinedly (observe that
both legs are straight, giving the figure a
sense of urgency).

Running comes in many different shapes, sizes, and flavors. The energy expended is in direct relation to the width of the running stride. The farther the front leg extends, the faster the figure is moving, and once the back leg accomplishes its "push," it relaxes and bends.

Here he's exhaustedly beginning the last leg of his daily jog . . .

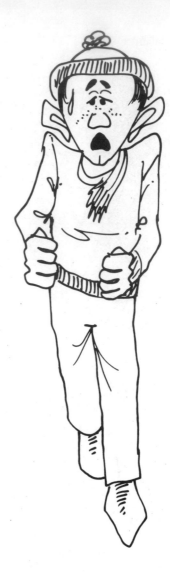

here she's racing pell-mell to her destination . . .

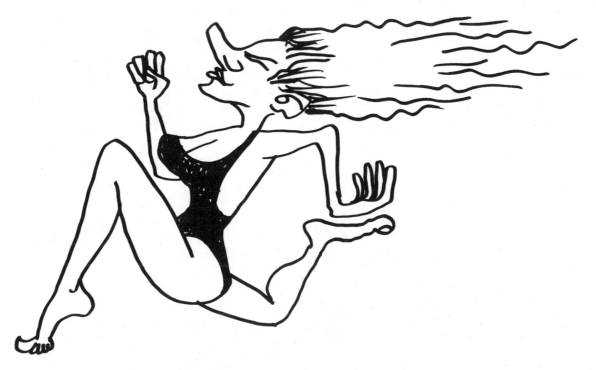

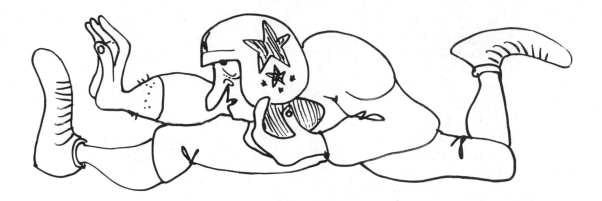

and nothing and no one will stop this guy from coming through.

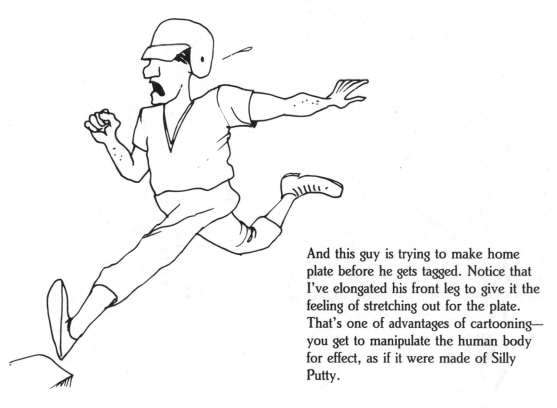

And this guy is trying to make home plate before he gets tagged. Notice that I've elongated his front leg to give it the feeling of stretching out for the plate. That's one of advantages of cartooning— you get to manipulate the human body for effect, as if it were made of Silly Putty.

Become aware of yourself and how you walk; notice how differently you run and/or walk when you're late than when you're window shopping or killing time. That kind of self-awareness and tuning in to what's going on around you helps you develop that perspicacious eye that will serve you well in your quest for artistic excellence.

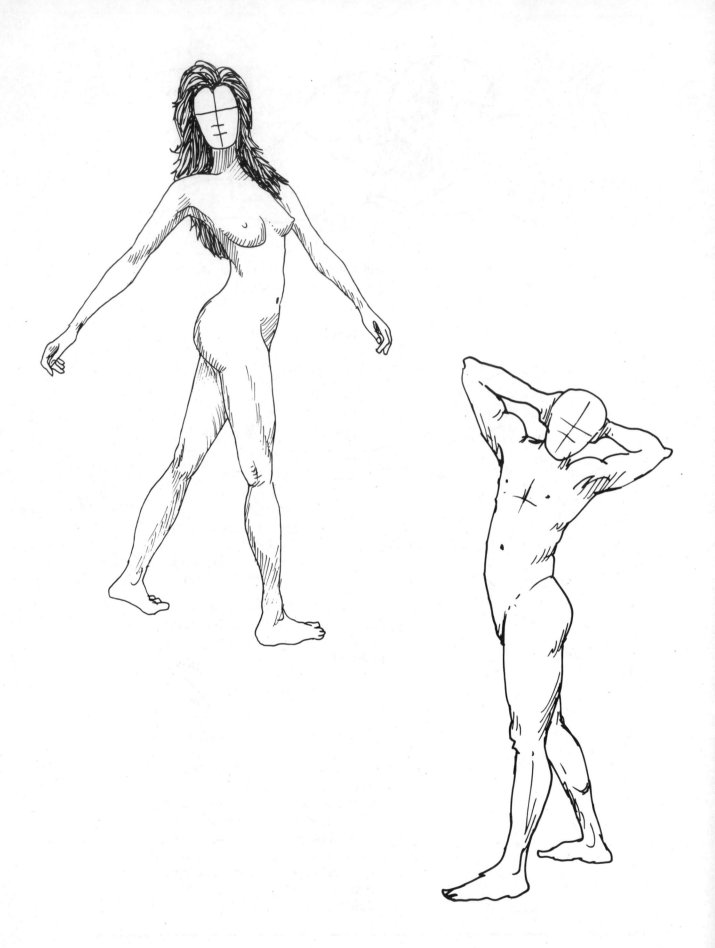

DANCING

I've devoted this chapter solely to dancing because there are few activities in the lexicon of human movement that require such grace, dexterity, and suppleness. Having worked in the musical theater as an actor, I have nothing but the deepest respect for these dedicated artists. They tirelessly practice, rehearse, and indulge in physically exhausting warm-up exercises in order to perfect and hone their craft. If you've never watched dancers in action, you've denied yourself a rare pleasure. Anyway . . . I've digressed enough—on to the dance.

The dancer is almost always at a temporary point of balance. If you want real movement, that should be your point of attack. Degas favored the dancer in repose or preparation but, since this book is more about movement, that's what I recommend.

It's difficult at best to capture that brief stance, the moment when the dancer's agility is at its peak, so here I suggest either photographing those poses to freeze-frame them, referring to dance magazines, etc., or doing copious sketches.

As with most of the activities that we've discussed, there are numerous kinds of dancing, but all of them involve the exaggerated movement of the body. Dancers are supple. They can twist and turn and bend and flex much more easily than most of us can. Note that the lower half of the body remains fast while the upper torso swings around. But only to an extent—don't do any accidental versions of Linda Blair's *Exorcist* head-spinning techniques.

It's good practice to sketch the body twisting and contorting so that you can get used to the various unusual moves that most dancers are capable of.

Below is an example of a dancer in that fleeting movement, poised for a microsecond. Observe the strong flowing action line here; most dancers' poses are graceful and sweeping.

And they have excellent distribution of weight. Find the center line and the action line.

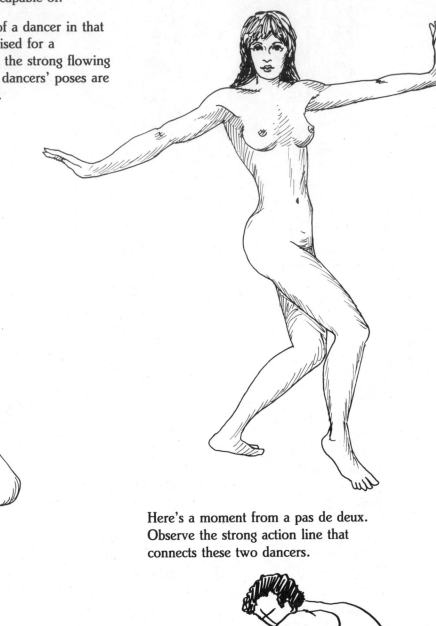

Here's a moment from a pas de deux. Observe the strong action line that connects these two dancers.

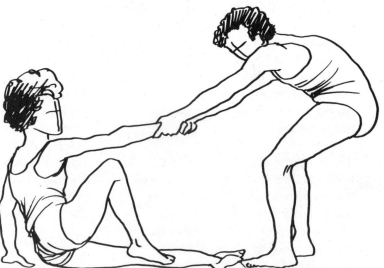

All of these observations should not be ignored merely because we decide to do a cartoon version. If we exaggerate those action lines as well as the grace and the swoop of their limbs, it adds to the desired humorous effect.

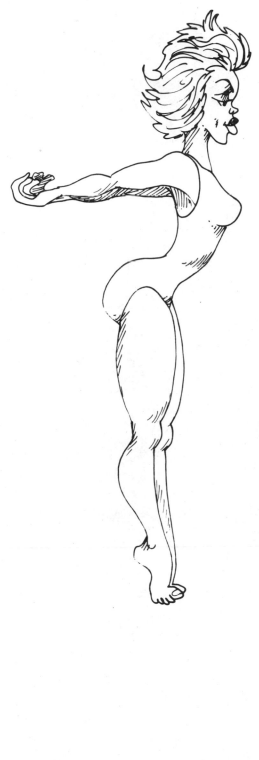

Most dancers, other than the occasional exotic variety . . .
are not especially voluptuous. They have extremely slender and well-tuned bodies.

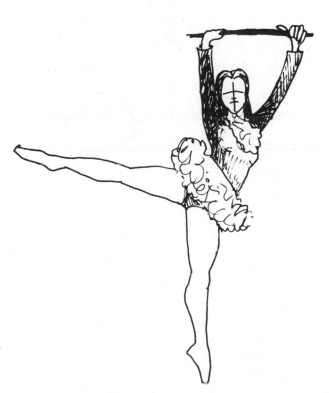

Regarding different kinds of dancing . . .
Native American dancing is more angular
and energetic.

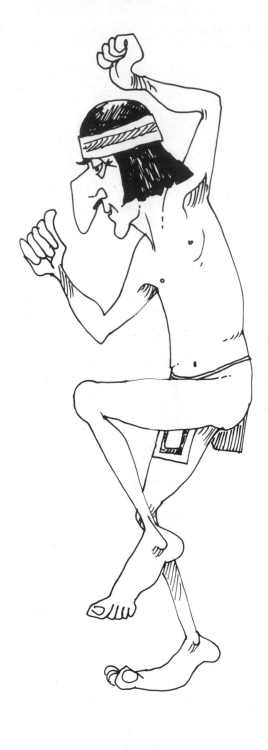

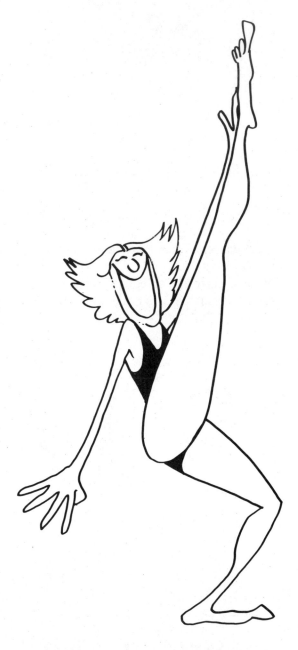

And talking about energy . . . this girl is
demonstrating impossible-looking
extension, but it adds to the comic
effect.

Here are some caricatures of exotic
dancers . . .

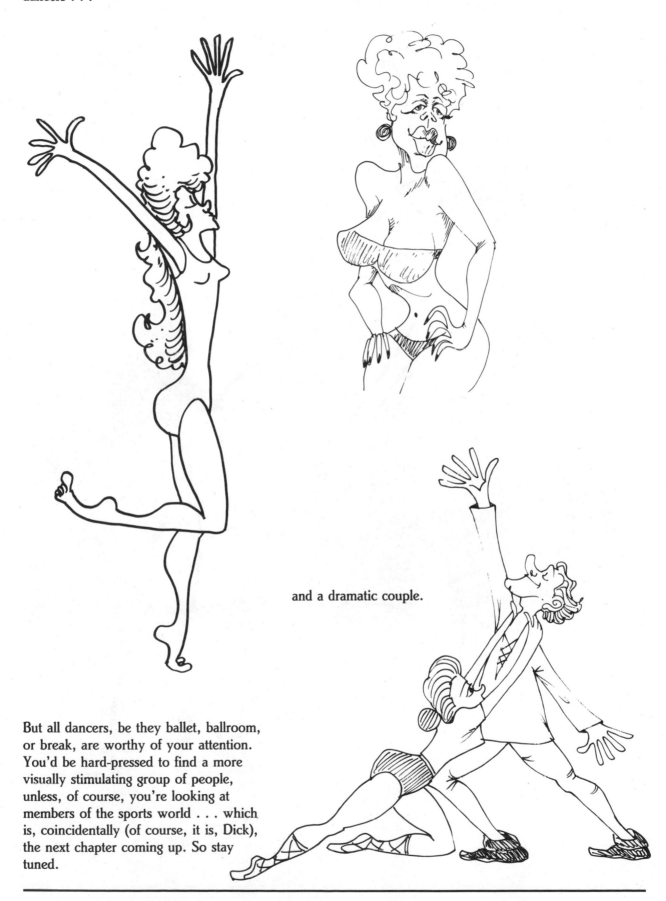

and a dramatic couple.

But all dancers, be they ballet, ballroom,
or break, are worthy of your attention.
You'd be hard-pressed to find a more
visually stimulating group of people,
unless, of course, you're looking at
members of the sports world . . . which
is, coincidentally (of course, it is, Dick),
the next chapter coming up. So stay
tuned.

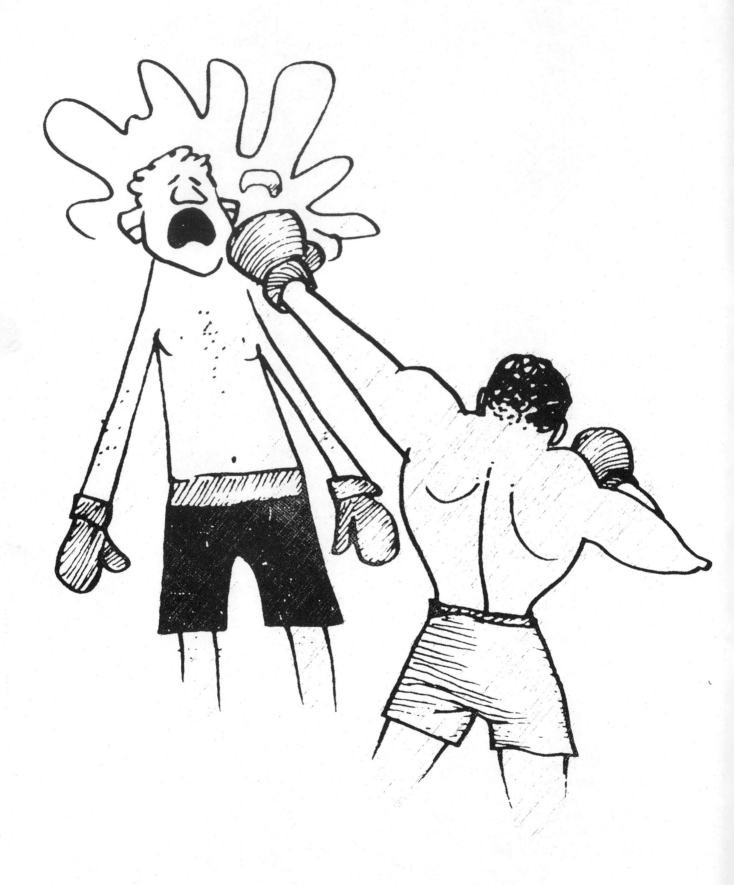

SPORTS

I don't believe that there's any form of human activity, short of actual war, that can compete with sports for violent, rough, collision-filled, body-contact, action. Yet (as in my favorite sport, basketball), the grace and athletic prowess required to play certain games is utterly beautiful to watch. Each sport puts its own unique demands on its players and hence, each has its own visual style, insofar as drawing or cartooning goes.

In capturing sports activities, we usually draw figures in conflict: football players crunching against the opposing team, prize fighters hammering each other, wrestlers straining at one another, etc., so the action lines and feelings of stress and movement are almost continuous from figure to figure.

And then there are those sports that require only single figures, such as bowling, figure skating, and (although it's definitely a team sport) baseball. (In its construction, most players operate logistically independent of one another, except for those few brief moments of contact such as tagging a player or the catcher racing the runner for home plate.)

In all of these sports activities, the artist has a little edge, of course: the uniform and the gear. These things immediately identify the type of sport for the viewer, which makes our jobs as artists much easier. Also the sports world is filled with men and women in excellent physical condition, so a good (if obvious) rule of thumb is to make them lean and muscular and fit. If we're delving into cartoons, then naturally it's funnier to see a high hurdle guy barely making it over because of an additional fifty pounds of weight, or a flimsily built wrestler facing an opponent that outweighs him by fifty pounds or more.

In capturing sports figures, the action lines and the choice of which point of action you choose to portray are very important. Do you recall several chapters ago I discussed preparation, movement, and follow-through? The choice of which to portray is especially important in this arena of movement, no pun intended.

Take a batter at the plate, for instance. I think you'd agree that the preparation is rather static (read dull), so the next choice, the movement itself, looks pretty good. However, the follow-through is also an exciting movement. The choice is yours. Exercise it.

On the other hand, in wrestling, the preparation is exciting . . . there's a certain preparatory tension in the figure that is interesting to watch: the two men circling each other, waiting for that split-second opening so they can make their move.

Below is one of those violent outbursts that occur occasionally on the football field. Notice how the figure on the left dominates because of the thrust of his back leg and, subsequently, the guy on the right looks defensive because, with one leg up in the air, he looks off-balance.

When you look at this squash player you'll see the preparation phase of the movement spectrum. The figure at this point is more relaxed and poised.

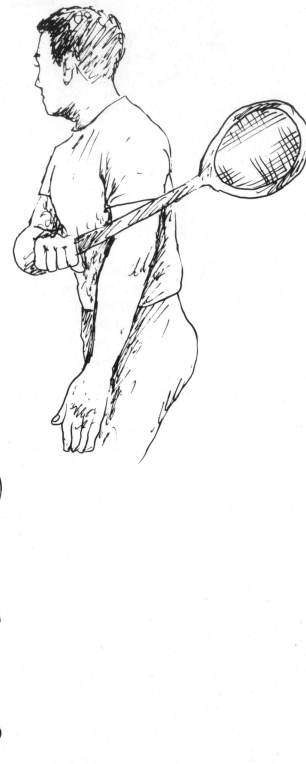

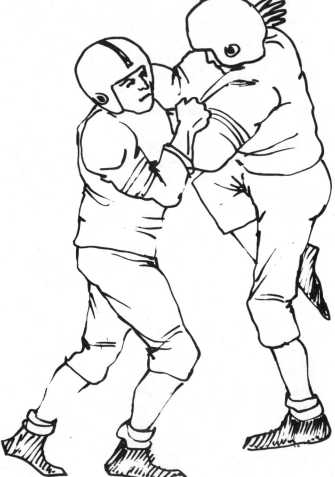

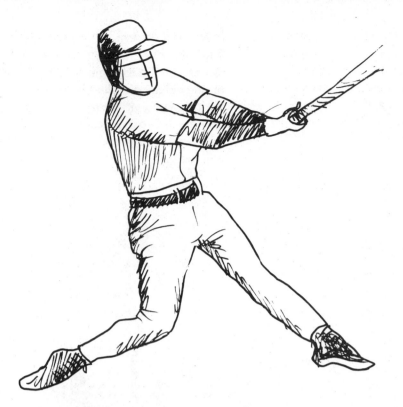

This is an example of the actual movement as the batter connects. See the power emanating from that front leg and backed up by the rear leg?

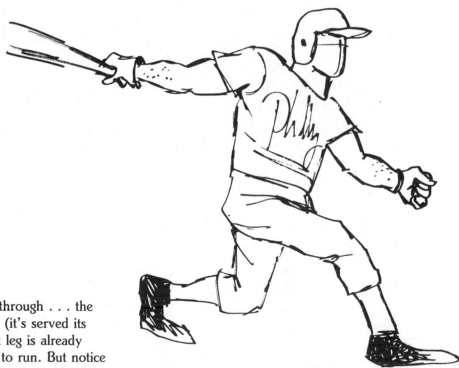

And here's the follow-through . . . the bat is behind him now (it's served its purpose), and the right leg is already stepping out preparing to run. But notice the bend in the legs, the aftermath of stressful action.

Here's another example of the follow-through phase. This tennis player has just executed a top spin backhand and is on the verge of settling back into position to await the next shot. The back hand is outstretched for balance and she teeters precariously on the tip of one foot.

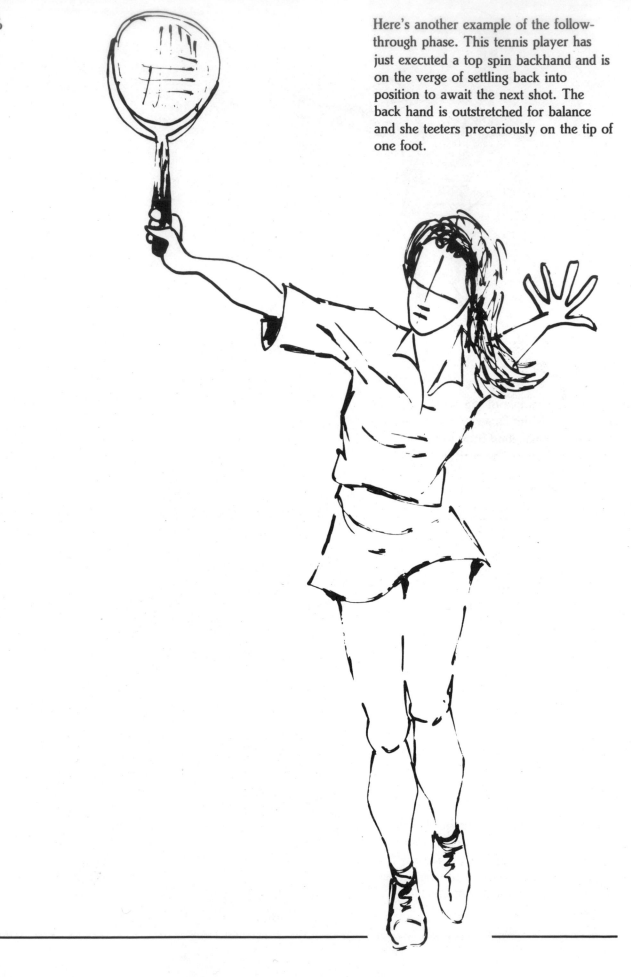

Turning the sports figure into a cartoon is great fun. There is so much movement to play with and so much latitude allowed the artist that it's a pleasure.

Above, notice how I've stretched the body to its absolute physiological limits in order to exaggerate the speed and force of this figure above. His head thrusts farther forward, and his front leg really reaches for the ball.

These two guys below are still grappling with each other, but it takes on a more violent tone when you distort it in a humorous way.

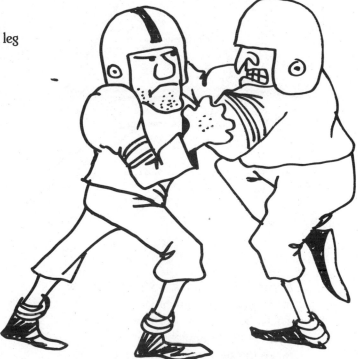

Here's a demonstration of a pitcher in
the preparation phase . . . the old leggy
windup. See how high the shoulder
comes up—he can barely peek over it.

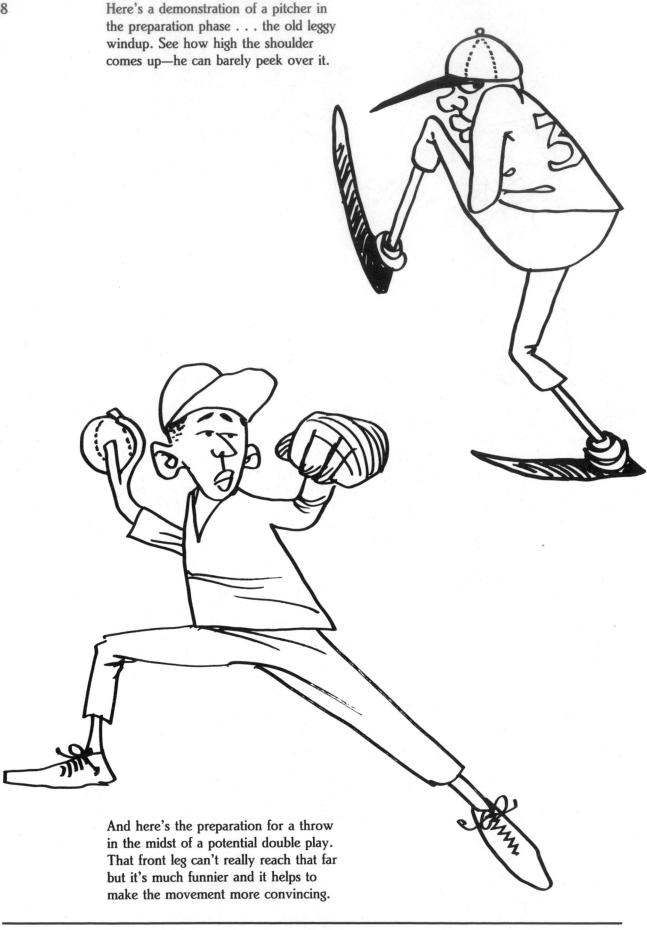

And here's the preparation for a throw
in the midst of a potential double play.
That front leg can't really reach that far
but it's much funnier and it helps to
make the movement more convincing.

Moving on to some other forms of sports . . . this matador leans dangerously close to the bull. The tilt of his body is more acute than normal.

I don't know if you'd consider this a sport or not, but I wanted to show you a figure exerting great strength against another force. See how his front leg is airborne for balance, while his rear takes the brunt of it and his hands are locked down firmly into position? All of these elements combine to complete the feeling of stress. You take away one of those components, the drawing will have less power.

This female gymnast is nearly losing her top. Even though she's a cartoon, her balance is correct. Her legs reach over and counterbalance her as she executes her handstand.

This football player is dodging and weaving expertly, but still we can capture him just as he eludes one of his aggressive pursuers. Notice the twist of his body and how he's perched (albeit temporarily) on one toe.

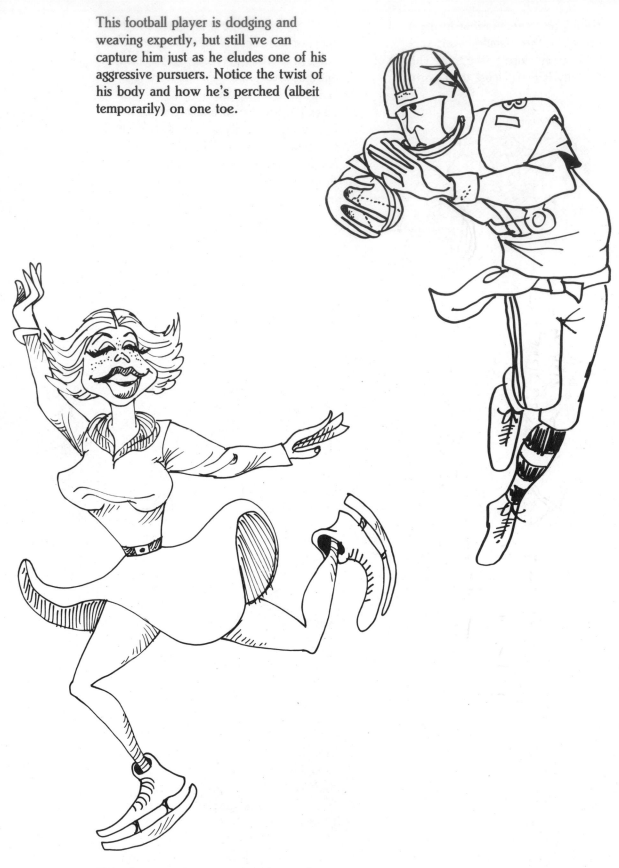

This skater projects speed and complete abandon by the position of her legs and her free-flying arms.

And to close off the chapter, here's a few more tennis players caught mid-action. (I admit my partiality—it's my favorite sport to play.)

But again, please take note of the bend of the legs and the feelings of focus, concentration, and effort (partially due to their expressions) in these figures.

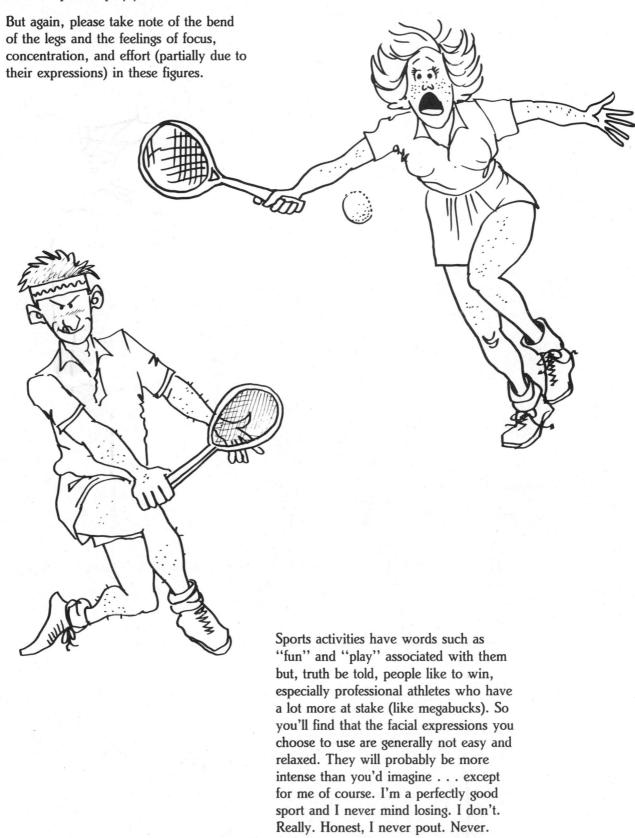

Sports activities have words such as "fun" and "play" associated with them but, truth be told, people like to win, especially professional athletes who have a lot more at stake (like megabucks). So you'll find that the facial expressions you choose to use are generally not easy and relaxed. They will probably be more intense than you'd imagine . . . except for me of course. I'm a perfectly good sport and I never mind losing. I don't. Really. Honest, I never pout. Never.

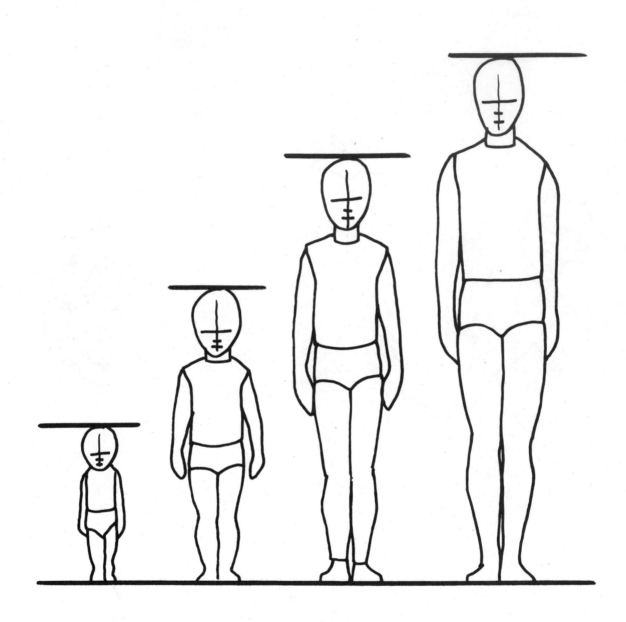

CHILDREN

I felt that I wanted to devote a little space to the drawing of children because, in a book about action and movement, it would seem definitely remiss to exclude the most energetic and physically demonstrative members of our society. Children participate in all of the aforementioned activities on an hourly basis . . . and then some. They run, stoop, dance, roll, tumble, engage in sports, and create movements and variations heretofore totally unheard of in our society, so I think they certainly qualify for a brief chapter of their own.

Drawing children requires a slightly different set of measurements: from infants right up to the middle teenage years, the child's body is more compressed, shorter, and the head seems larger, (actually it remains about the same, we merely grow into it).

At left is a chart demonstrating the average growth pattern from infancy to childhood to adulthood.

Observe that in the newborn child the measurement is that of 4 heads. In the 2-year-old, it's about 4½ heads; the

8-year-old has grown to just about 6½ heads tall; and at 14 he reaches nearly the 7-head mark. He might grow a bit beyond that but, generally speaking, once we've reached the age of 20, we've attained our full stature.

Also babies are plumper. As we grow into infancy and then childhood, we lose our "baby fat" and begin to elongate.

You should be able to tell the
approximate ages of these boys merely
by their head and shoulder size. . . .

This budding matador is older still.

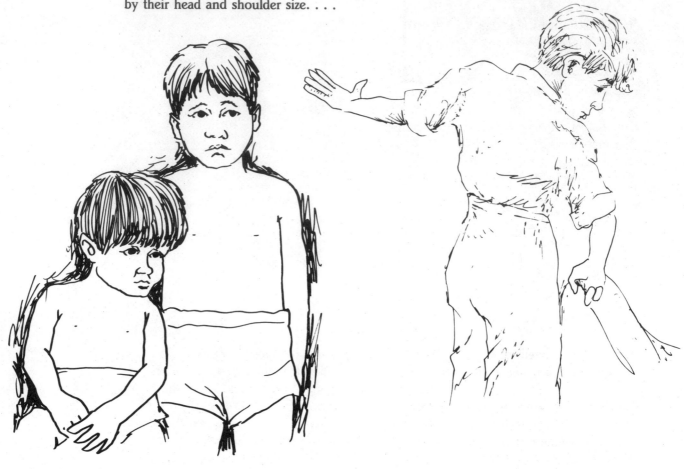

Look at this boy. See how full his face
and legs still are, and how easily he
squats? Children are very loose and
pliable.

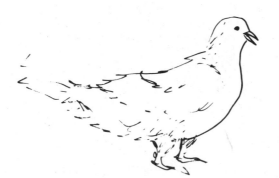

Cartooning children is fairly simple because their features are still rather amorphous. Since simplicity is at the very heart of cartooning, these two forces work together quite nicely.

Because children are rather unformed in comparison to adults, and because their musculature is minor, we can use very simple and rather straight lines to record their movements. It's not necessary to pay attention to much detail either in their bodies or their features. In fact, the simpler the better. And, as opposed to adults, there probably isn't a gesture, action, or grimace that children are incapable of. So feel free to let your characters express themselves in the most outrageous ways.

When you cartoon an infant, you can make the head the same size as its entire body, a 1-to-1 ratio. This usually instantly communicates that it is indeed a baby.

And as he grows, give him only a slight bit more body length.

The very act of capturing the moving child in cartoon style is a pleasure. As I stated before, they are so incredibly demonstrative and expressive it's no wonder that strips like *Peanuts* and *Dennis the Menace* (and even going as far back as *Nancy and Sluggo* and *Henry*) are so popular: It's a rich vein to tap comically. If you have children of your own, of course, you have more models and ideas than you know what to do with. If you don't, frequent places where children gather, and sketch them. Believe me, they will surprise and delight you with their visual inventiveness, a constant source of amusement. Children.

In closing, here's a cross section of rather rambunctious activities inspired by the small set . . .

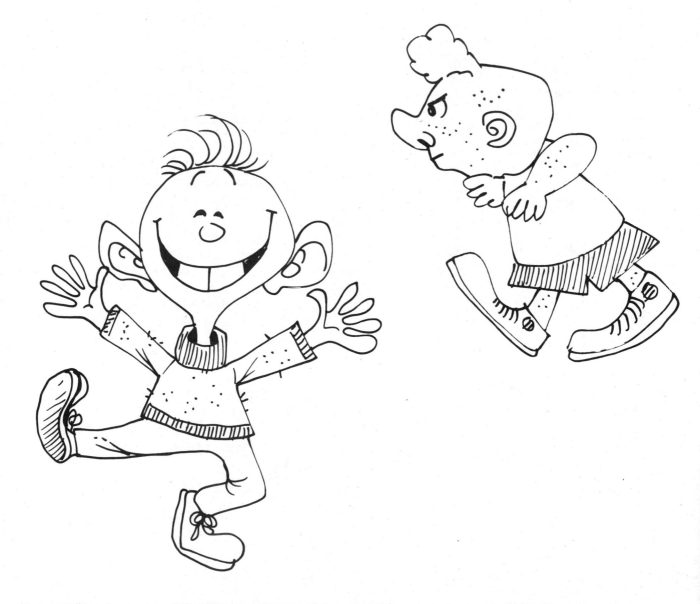

and let's finish things off with a
caricature of the little boy feeding the
pigeon.

CONCLUDING THOUGHTS

Well, there we are. . . . As I stated in the beginning, all I can do really is to fill your boat with whatever advice, hints, tips, shortcuts, etc. that I can muster up and then set you afloat. I hope that I've given you more supplies and information than you require. The time has come for your solo: You have the equipment, the intelligence, the potential ability, and now all you need is the passion, desire, persistence, and self-discipline to accomplish this feat. To draw and/or cartoon the human body is not as elusive or as mysterious a talent as some would have you believe. I honestly feel that with stick-to-itiveness and application, almost anyone can learn to draw and sketch the body in action. I know you can. Now it's up to you. So just get out there and do it. Bon voyage.

ABOUT THE AUTHOR

Dick Gautier was drawing cartoons for his high school paper in Los Angeles when he was sixteen, singing with a band when he was seventeen, and doing stand-up comedy when he was eighteen. After a stint in the Navy, he plied his comedy wares at the prestigious "hungry i" in San Francisco for a year before traveling to the East Coast, where he performed in all the major supper clubs; among his appearances was an extended run with Barbra Streisand at the Bonsoir in Greenwich Village. He was tagged at the Blue Angel by Gower Champion to play the title role in the smash Broadway musical *Bye Bye Birdie,* for which he won a Tony and Most Promising Actor nominations.

After two years he returned to Hollywood, and eventually starred in five TV series, including *Get Smart,* in which he created the memorable role of Hymie, the white-collar robot. In addition, he portrayed a dashing but daffy Robin Hood for Mel Brooks in *When Things Were Rotten.*

Add to this list guest-starring roles in more than 300 TV shows, such as *Matlock, Columbo,* and *Murder, She Wrote,* and appearances on *The Tonight Show,* and roles in a slew of feature films with Jane Fonda, Dick Van Dyke, George Segal, Debbie Reynolds, Ann Jillian, James Stewart, etc., etc. He has won awards for his direction of stage productions of *Mass Appeal* and *Cactus Flower* (with Nanette Fabray), and has written and produced motion pictures.

Gautier is the author/illustrator of *The Art of Caricature, The Creative Cartoonist,* and *The Career Cartoonist: Drawing & Cartooning 1001 Faces* for Perigee Books, a children's book titled *A Child's Garden of Weirdness,* and a coffee-table book with partner Jim McMullan titled *Actors as Artists.* He's done just about everything but animal orthodontics, and don't count him out on that yet. No wonder he refers to himself as a "Renaissance dilettante."

Of all his accomplishments, Gautier is proudest of the fact that he's never hosted a talk show, or gone public with tales of drug rehabilitation and a dysfunctional family life.

Learning to draw is fun and easy
with Perigee's illustrated art instruction books!

These books are available at your bookstore or wherever books are sold, or, for your convenience, we'll send them directly to you. Call 1-800-631-8571 (press 1 for inquiries and orders) or fill out the coupon below and send it to:

The Berkley Publishing Group
390 Murray Hill Parkway, Department B
East Rutherford, NJ 07073

	SBN	U.S.	CAN
_____ *The Art of Caricature* by Dick Gautier	399-51132-6	$11.00	$14.50
_____ *The Career Cartoonist* by Dick Gautier	399-51732-4	$10.95	$14.50
_____ *The Creative Cartoonist* by Dick Gautier	399-51434-1	$11.00	$14.50
_____ *Drawing and Cartooning 1,001 Faces* by Dick Gautier	399-51767-7	$10.95	$14.50
_____ *Drawing and Cartooning 1,001 Figures in Action* by Dick Gautier	399-51859-2	$10.95	$14.50
_____ *The Art of Cartooning* by Jack Markow	399-51626-3	$7.95	$10.50
_____ *Drawing and Cartooning Monsters* by Tony Tallarico	399-51785-5	$7.95	$10.50
_____ *Drawing and Cartooning Dinosaurs* by Tony Tallarico	399-51814-2	$7.95	$10.50
_____ *Drawing Animals* by Victor Perard, Gladys Emerson Cook and Joy Postle	399-51390-6	$7.95	$10.50
_____ *Drawing People* by Victor Perard and Rune Hagman	399-51385-X	$7.95	$10.50
_____ *Sketching and Drawing for Children* by Genevieve Vaughan-Jackson	399-51619-0	$7.95	$10.50
_____ *Cartooning the Head and Figure* by Jack Hamm	399-50803-1	$8.00	$10.50
_____ *Drawing and Cartooning for Laughs* by Jack Hamm	399-51634-4	$8.95	$11.75
_____ *Drawing Scenery* by Jack Hamm	399-50806-6	$9.95	$12.95
_____ *Drawing the Head and Figure* by Jack Hamm	399-50791-4	$7.95	$10.50
_____ *First Lessons in Drawing and Painting* by Jack Hamm	399-51478-3	$10.95	$14.50
_____ *How to Draw Animals* by Jack Hamm	399-50802-3	$7.95	$10.50

Subtotal $ _____
Postage & handling* $ _____
Sales tax (CA, NY, NJ, PA) $ _____
Total amount due $ _____
Payable in U.S. funds (no cash orders accepted).
$15.00 minimum for credit card orders.

*Postage & handling: $2.50 for 1 book, 75¢ each additional book up to a maximum of $6.25.

Enclosed is my ☐ check ☐ money order
Please charge my ☐ Visa ☐ Mastercard ☐ American Express

Card #_____ Expiration date _____

Signature as on charge card _____

Name _____

Address _____

City _____ State _____ Zip _____

Please allow six weeks for delivery. Prices subject to change without notice.